RECOLLECTIONS OF A HIDDEN LAOS

RECOLLECTIONS OF A HIDDEN LAOS

A Photographic Journey

LINDA REININK-SMITH

 Silkworm Books

For Björn
"Go out and find the world"

ISBN: 978-616-215-018-0

Published in 2012 by

Silkworm Books
6 Sukkasem Road, T. Suthep
Chiang Mai 50200 Thailand
info@silkwormbooks.com
http://www.silkwormbooks.com

Cover and interior design by Lisa Carta
Typefaces used are Frutiger and Chaparral Pro

Printed and bound in China

5 4 3 2 1

CONTENTS

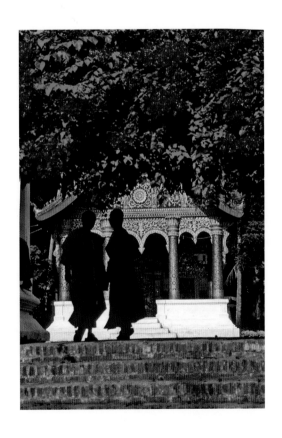

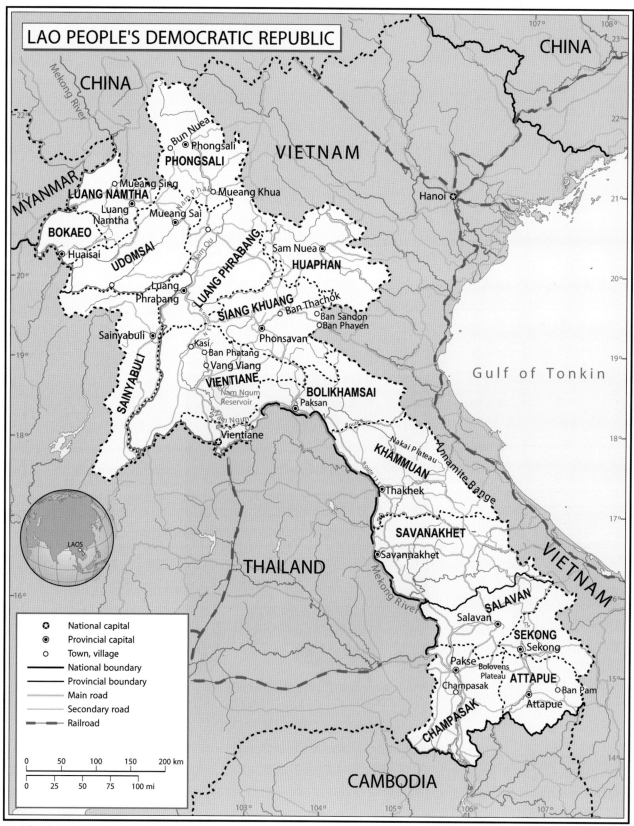

LAO PEOPLE'S DEMOCRATIC REPUBLIC

CHINA

CHINA

Mekong River

VIETNAM

MYANMAR

Bun Nuea
Phongsali
PHONGSALI

Mueang Sing
LUANG NAMTHA
Mueang Khua
Luang Namtha
Mueang Sai

BOKAEO

Huaisai

UDOMSAI

Sam Nuea
HUAPHAN

Luang Phrabang

LUANG PHRABANG

Sainyabuli

SIANG KHUANG
Ban Thachok
Ban Sandon
Ban Phayen

Kasi
Phonsavan

SAINYABULI

Ban Phatang
Vang Viang

VIENTIANE

Nam Ngum Reservoir

BOLIKHAMSAI
Paksan

Nam Ngum

Vientiane

Hanoi

Gulf of Tonkin

Nakai Plateau

KHAMMUAN
Thakhek

Annamite Range

Route 13

SAVANAKHET
Savannakhet

THAILAND

Mekong River

SALAVAN
Salavan

VIETNAM

SEKONG
Sekong

Pakse
Bolovens Plateau
ATTAPUE

Champasak

CHAMPASAK
Attapue
Ban Pam

CAMBODIA

LAOS

Legend	
⊛	National capital
⊙	Provincial capital
○	Town, village
▬	National boundary
—	Provincial boundary
⋯	Main road
—	Secondary road
▬ ▬	Railroad

0 50 100 150 200 km

0 25 50 75 100 mi

Modified from United Nations Map No. 3959 Rev. 1.

INTRODUCTION

From the air, one sees mostly jagged, forest-covered mountains etched with unexpected waterfalls, glistening like milky quartz amidst the green. Closer inspection reveals ethereal villages of grass-thatched huts from a past era clinging to high ridges and surrounded by misty grand vistas reaching into the distance. In damp, verdant valleys full of pungent scents, boisterous rivers drown out the drone of countless dragonflies. Pastoral villages nestle along the banks of rivers that sparkle in the sunshine. Children, unhindered by schooling, play all day in the clear, warm water, shrieking in languages spoken by few. Downriver, the pastoral gives way to bleak reality: remnants of forests deliberately burned to the roots, the soil carried away by streams to the ocean far away.

Swamps harbor scores of lost, bewildered spirits, as well as creatures far more real. The mud at the bottom of the swamp is soft, and the water is shallow. It is pouring, and the rain forms interesting dendritic patterns on my rain cape, which is, nevertheless, uselessly soaked through. I glance at one of my colleagues, whose hat is drooping and dripping wet. Water pours down his face and chin as he slogs through the swamp. The water flowing from his chin makes it look like he has grown a beard, although something about it looks odd. Then I see them—several leeches hang straight down in a stringy curtain from his chin, as if seeking camouflage in the dripping water.

Leeches can be clever. This is one of many valuable lessons I learned during the nearly four years (1992–95) I worked as a geologist for three different enterprises: the United Nations, a mining company, and a construction company in the Lao People's Democratic Republic, better know as Laos. Although a major part of my work was conducted in an office in the capital, Vientiane, I was fortunate in that my work also involved travel to various provinces. Thus, I had the opportunity to see much of Laos just before and during its transition from a rural, isolated society to a country slowly opening up to the world.

During this transition, Laos became a veritable construction site of new roads, dams, bridges, airports, and modern buildings. Concrete utility poles waiting to be set into the ground littered roadways along paths to villages that would be illuminated with electricity for the first time ever. This transition continues today, as Laos increasingly becomes a tourist destination. Thai and Chinese tourists swarm to gold and silver markets in Vientiane. Adventure trips abound, and scantily dressed backpackers with travel guides clutched in hand follow precise directions to penetrate all corners of the country.

Laos's journey out of isolation has been difficult, however, and may never be complete because of the mountainous terrain in large parts of the country. This may be a blessing in disguise, actually helping preserve the lives and cultures of some hilltribe ethnic minorities, which would otherwise be swallowed up in this cauldron of well-meant activity.

THE COUNTRY OF LAOS

A Short Sketch of a Long History

Every portrayal of Laos starts by stating that it is a landlocked country, as if this were its most interesting quality. Laos does not, however, feel "locked" in any sense, and from a historical perspective, Laos has not been ignored by virtue of its landlocked status. *Homo erectus,* ancestor of *Homo sapiens,* inhabited the area as early as five hundred thousand years ago.[1] Hunter-gatherers, similar to some of the indigenous people of Laos today, inhabited the area at least ten thousand years ago, as indicated by dated skulls and stone tools.[2] For thousands of years, the Mekong River and its tributaries facilitated the transport of goods and encouraged migration and settlement by ethnically diverse people. Lush river valleys yielded abundant food, and mountain ranges and high plateaus spread in all directions offering untold possibilities. This landlocked terrain also appealed to those seeking power. Throughout history, the Chinese, Mongols, Khmer, Burmese, Vietnamese, Siamese (Thai), and probably others fought to rule this area that would one day become Laos, regardless of the wishes of the inhabitants.

Closer to the present, in 1316, Fa Ngum, grandson of King Phaya Suvanna-khamhong, established Lan Xang, "The Land of a Million Elephants." In 1560, after many changes in the power structure, King Setthathirat established Vieng Chan as the capital of Lan Xang.[3] At that time, Lan Xang extended from the border with China on the north, to the Mekong rapids near the Cambodian border on the south, to the Khorat Plateau in what is now Thailand on the west. In 1707, Lan Xang

was split in two, and Vieng Chan became the capital of an independent kingdom, also named Vieng Chan. That kingdom was later obliterated by a Siamese invasion in 1827. In 1899, Vieng Chan, renamed Vientiane, became the capital of the French protectorate of Laos, part of a larger French Indochina. Japan briefly took control of Laos during World War II, and the Lao actually gained more local autonomy.[4] The French never regained control of Laos, although not for lack of trying, but the French influence persists to the present day.

In 1965, the communist Pathet Lao grew out of a long-standing Vietnamese-supported liberation movement. The Pathet Lao overthrew the royal government in 1975, and the kingdom of Laos became the Lao People's Democratic Republic, which it remains to this day.[5] The Lao people are presently living in relative peace; they are more occupied with partaking in the wonders of fledgling capitalism than with worrying about history repeating itself.

The People

The population of Laos, about 6.4 million in 2010, will double in about forty years because of a 1.712 percent annual growth rate.[6] The life expectancy at birth is only sixty-two years, and approximately 40 percent of the population is under the age of fifteen. Thus, meeting a very old person in Laos is a rare treat.

In 1950, the Lao government subdivided its population into three, simple, ethnic-geomorphologic classifications based on common origin and language[7]: 56 percent of the people were designated as Lao Lum "lowland Lao" belonging to the Tai-Kadai linguistic family, 34 percent as Lao Thoeng "midland Lao" of the Austro-Asiatic linguistic family, and 9 percent as Lao Sung "upland Lao" belonging to the Sino-Tibetan and Hmong-Mien linguistic families.[8] This classification system is only partially accurate because many people have moved from their geomorphologic territories.[9] Although the system has been losing credibility within the Lao government, it is well known and still widely used among provincial governments and among the Lao people, and I use it here.

Anthropologists, however, further subdivide the four linguistic families into "branches" based solely on language differences. These branches classify the population into ethnic minorities, commonly called "groups," which are further subdivided into sub-ethnic minorities, called "subgroups."[10] According to the 1995 national census, Laos is home to 47 major groups[11] and 149 subgroups.[12]

The photos in this book illustrate some of the ethnic diversity within the three ethnic classifications of this heterogeneous society. Although I mostly photographed the ethnic minorities, the Lao Lum ethnic majority is shown in photos of monks, novices, and other non-minority people.

The Lao Lum originally came from southern China and migrated into Laos over one thousand years ago. These lowland Lao, who have been rulers and policy makers for hundreds of years, speak a variety of Tai-Kadai languages, including Lao.

Several photos in this book are of the Lao Thoeng people, whose ancestors probably migrated northward into Laos at least five thousand years ago[13] from the Malay Peninsula and Indonesian archipelago. The Lao Thoeng are the indigenous inhabitants of Laos, and they originally populated the fertile plains and river valleys. Later, they were exploited by the Lao Lum and displaced into the mountains. Even today, they are commonly referred to as "Kha," a derogatory term meaning "slave." The Lao Thoeng are extremely diverse, commonly have mutually incomprehensible languages, and have rarely been described in ethnographic accounts. Some of my more interesting encounters with the Lao Thoeng were with the Lave group in southeastern Attapue Province, where more than twelve thousand Lave people live.[14]

Although relatively few people in Laos are Lao Sung, or the highlanders of Laos, they are often the subjects of my photographs. The Lao Sung are made up of several ethnic groups that speak Sino-Tibetan or Hmong-Mien languages. The Akha, whose language is classified as Tibeto-Burman in the Sino-Tibetan linguistic family, migrated into Laos within the last two hundred years from Yunnan Province in China. They are thought to have originally migrated into Yunnan Province from Szechuan Province or from eastern Tibet.[15] Several of my photos document the daily lives of the Akha people, who number more than sixty thousand individuals[16] and are divided into several subgroups. I photographed a few of these subgroups—the Nuqui in two villages in Phongsali Province, the Oma in the same province, and the Pouly Nyai from Luang Namtha Province. I also photographed the Pala, a group sometimes thought to be an Akha subgroup, in a village near Mueang Khua.

I also took pictures of some Lao Sung people whose languages are subsumed under the Hmong-Mien linguistic family, namely, the Hmong, the Lanten (Black Yao), and the Mien. Although these ethnic groups are relatively new residents of Laos, having migrated here some one hundred years ago, their ancestors are thought to have lived along the Yellow River in China at least five thousand years ago.[17] The Hmong, Lanten, and Mien in Laos live mostly in the northern region, and while there is no reliable data, some sources estimate that there are 270,000 Hmong, 4,500 Lanten, and 20,300 Mien.[18]

The Hmong group is most widely known outside Laos because of its support for the U.S. against the communists during the Vietnam War. The Hmong have been victims of persecution for thousands of years, and they fled to Indochina at the end of the nineteenth century after harassment by the Chinese. By 1850, some had established villages near

Luang Phrabang.[19] From 25,000 to 30,000 Hmong were killed during the Vietnam War between 1960 and 1975. After the war, many fled to Thailand, the U.S., Canada, and France because of persecution by the communist Pathet Lao. Many of the Hmong who remained in Laos no longer lead traditional lives but have adopted the Lao Lum lifestyle. Other Hmong, however, still cling to traditional ways, especially in Udomsai and Siang Khuang Provinces, where many of my photos of this group were taken.

The Beliefs

The first impression one gets of Laos is of a country devoted to Buddhism, and this is in part correct. About 60–65 percent of the Lao population follows Theravada Buddhism, which permeates every spiritual and physical aspect of the lives of most Lao Lum, or lowland Lao. About 30 percent of the population, mostly the Lao Thoeng and the Lao Sung, practice solely animism.[20] An intriguing relationship exists between Buddhism and animism. Devoted Buddhists, without any apparent internal conflict or embarrassment, commonly practice both religions concurrently. For example, Buddhists in Laos have incorporated into their belief system the universal *phi* (spirits) of earth, heaven, fire, and water.

The animistic beliefs in Laos involve spirits too numerous to mention. Some of the local spirits that flourish are spirits of the water, spirits of the forest, spirits of dwellings, village spirits, and spirits of wandering souls of people who have died violent deaths. These latter spirits seem to be particularly common in Siang Khuang Province, where horrors from the Vietnam War abound. The belief is that many unfortunate souls cannot be born again and must be ritually appeased. One particularly evil spirit, *phi kong ko,* lives in the forest in the shape of a monkey and likes to rip out the intestines of offending people.[21] In fact, one of my Lao friends had an encounter with *phi kong ko* and lived to tell about it. After becoming possessed by such evil spirits, some people have even been cast out of their villages.

Minor religions in Laos include Brahmanism, Islam, Baha'i faith, Christianity, Mahayana Buddhism, Taoism, and Confucianism. These religions together are practiced by less than 2 percent of the population and have left few imprints on Lao society.

The Forests

The main exports from Laos are wood products and hydroelectric power. In 2010, 68 percent of Laos was reportedly covered by forest, whereas in 2000, forest cover in Laos was reported to be only 54.4 percent. The current figure is impressive compared to forest cover percentages in the neighboring countries of Vietnam (44 percent), Thailand (37 percent), and China (22 percent). The use of remote sensing and other new technology seem to indicate that Laos's forests have not been as denuded as previously thought.[22]

Prior to 1989, most forestland belonged to and was managed by the state. Since 1989, the Lao government has encouraged "participatory people-oriented forestry," whereby villagers are allowed to share profits from timber sales in natural and planted community forests. Small plots of fast-growing teak saplings have shot up on degraded land all over the country since about 1999. In places where all trees had previously been felled and no shade existed, people and livestock can be seen resting under trees, reaping a much-needed harvest of shade before the literal harvest of timber.

The Lao government has been trying to reduce by more than half the people using swidden cultivation, and to eliminate this practice by 2020.[23] As a result, during the 1990s whole mountain villages were resettled to the lowlands with the disastrous consequence that up to 30 percent of the inhabitants died in the first few years because they had no resistance to lowland diseases.[24] In fact, traditional swidden agricultural can be ecologically sound when combined with long fallow periods. After about two growing seasons, secondary forest can then get established. This is the method preferred by the original mountain inhabitants, because it is easier to cultivate land covered with secondary forest than with primary forest.[25] Problems arise, however, because of population pressure when lowland farmers encroach into the hills. The farmers cannot afford to wait through fallow periods but must instead clear primary forest.

The Lao government now recognizes that the blame for deforestation cannot be put on the original mountain inhabitants and has thus abandoned its plan to resettle nine hundred thousand upland people nationwide.[26] This may give some little-known cultures a chance to survive.

The Wildlife

With a million elephants gone from "the land of a million elephants," perhaps Laos should be renamed "the land of a million water buffaloes," because the big, lumbering beasts are as ubiquitous as clouds in the sky. Wildlife is not. I seldom observed *bona fide* wildlife in Laos, although inaccessible parts of Laos, especially along the Vietnamese border, are considered to have great biological value. A status report by IUCN[27] presents long lists of exotic but endangered animal species, 94 of which have international conservation significance. For example, based on villagers' testimony, elephants, tapirs, tigers, and rhinoceroses still live in remote and inaccessible parts of Laos. Many of these endangered animals, however, are hunted for the illegal wildlife trade, which is rampant in Laos. The insatiable appetite for traditional medicines and

food, mostly in China but also in other Asian countries, drives this illegal trade, which is so lucrative that even Lao officials have been involved for many years.[28] Thus, international environmental aid projects have been reluctant to intervene, and the wildlife trade continues unchecked.

Some wildlife in Laos may get a reprieve through twenty biodiversity conservation areas established in 1993 and comprising up to 15 percent of the country.[29] In principle, this is a good policy, although hunting and logging bans are rarely enforced in Laos. One of the most important of these conservation areas is the Nakai–Nam Theun national biodiversity conservation area, which was established on the Nakai Plateau in Khammuan Province in central Laos. On the eastern boundary of this conservation area is the Annamite Range; it forms a natural border between Laos and Vietnam and extends from Siang Khuang Province in the north to Attapue Province in the south, and beyond into Cambodia. Here roams the saola (*Pseudoryx nghetinhensis,* Vu Quang Ox, called *saolao* by the local villagers), a mammal species discovered in Vietnam near the Lao border in 1992, and hailed as one of the greatest animal discoveries in modern times.[30] It is now considered one of the world's rarest mammals. Yet, on the western side of this conservation area is the site of a huge hydroelectric dam, the Nam Theun 2, which has flooded 450 square kilometers of land.[31] The initial construction and massive logging in anticipation of the dam brought an influx of people from all over the country, resulting in indiscriminate hunting and slash-and-burn practices. The very wildlife that was supposed to be protected has instead been threatened.

MY RECOLLECTIONS OF LAOS

Life in the Bush

I was the only female and only foreigner on a geology team otherwise composed entirely of Lao males. As such, I not only experienced the bush and its people but was also privy to the thoughts and ideas of my companions while trying to obey the strict social division between males and females. In Laos, especially in the countryside, females still have specific, traditional roles and are usually deferential to males. I observed this both in traditional Lao villages and in mountain tribal villages. Females cook, clean, spin, weave, rear children, collect firewood, carry water, gather roots and herbs in the forest, and do the hardest work in the fields. Men are village and district chiefs, decision makers, and in charge of security. They carry precious radios, plow fields, fell trees, build houses, and carry firearms, commonly Russian-made AK-47 assault rifles. During my brief visits to various villages, I noticed that men spend a large amount of time smoking water pipes, drinking tea, and resting. Rarely in the bush did I encounter unarmed men or even unarmed boys. With their firearms, they use every opportunity to acquire food for their families. If they are lucky, they sell their kill for cash by displaying it along country roads, hoping a passing truck or bus will stop. They shoot any edible animals, mostly birds and rodents, but also deer, pangolins, and other less common wildlife. Many times, I encountered a hunter carrying a "bouquet" of a dozen little birds dangling with broken necks. Hunting adds necessary protein to a protein-deficient diet. I rarely sighted wildlife near human settlements because hunting regulations go unenforced, and the numerous hunters are indiscriminate. For example, I saw a skull and horns of the extremely rare and supposedly protected saola hanging on the wall of a hut in Khammuan Province, so nothing is spared. Thus, "wildlife" photos in this book are limited to insects and a lizard.

Trials and Tribulations of Fieldwork

Most of my geologic fieldwork was conducted in Vientiane Province, which meant that I could conveniently go back home to Vientiane for the night. Even so, it was necessary to prepare, each day, for a long, arduous trip by packing such items as a chainsaw, ax, tow rope, winch, and extra water. We drove on small country tracks that were created by oxcarts and water buffaloes and did not support much motor traffic, especially because buffaloes like to wallow in the mud holes in the tracks. Trees fallen across the tracks, or bamboo stands snapped and felled by storms, were left where they fell. Villagers and oxcarts could maneuver around such obstacles, but not, contrary to belief, a Land Cruiser, our mode of transportation. Nevertheless, our driver, Ly, gallantly challenged every obstacle, and our equipment preparedness usually paid off. We were not always as well prepared for other maladies of fieldwork, however, such as heat exhaustion, insect bites, dysentery, and leeches, but in the end we prevailed.

Bridges (if they existed) in the countryside were usually merely logs rolled together over creeks and small streams. My conviction that they would roll apart as we crossed never materialized, but these bridges provided me with many opportunities for excuse. "I want to record the moment on film" became my subterfuge for "I don't want to be in the vehicle when it crosses." Many wide rivers, especially in southern Laos, had no bridges at all, and only Ly's resolve and determination brought us across them, water rising up against the upriver side of the Land Cruiser. On other occasions, we would walk across a small creek on the way to a field area, only to find upon our return that the creek had become a stream filled with turbulent, muddy water full of floating debris.

No matter how well equipped we were, nothing prepared us for driving in the desolate no man's land around the Ho Chi Minh Trail in Attapue Province. To ensure our survival, we relied entirely on luck

and entreaties to the forest spirits, and this apparently worked. Ly drove heedlessly on thick mats of leaves, which could have hidden a variety of insidious killing devices invented by those who would never see their effects firsthand. We most feared unexploded cluster bomblets (referred to by the Lao as "bombies), because they are well camouflaged. They resemble the innocuous little round stones that children like to play with, a deception that has torn many children apart. I heard my colleagues mutter, "There are no good spirits here, so no one wants to live here anymore." I wholly agreed. The scorched landscape was gouged with large bomb craters, some filled with stagnant water, that look as if they were made yesterday. Withered trees lined overgrown, dusty trails littered with old scrap metal and bomb canisters. An arsenal of unexploded ordnance was hidden under leaf mats and buried in creeks. We had to dig with shovels to take geochemical samples from those creek beds, and we were fully aware that metal against metal could have had fatal consequences. As is the custom in Laos during tense moments, we nervously laughed every time we hit a metal-sounding object.

My colleagues were also concerned about other potentially fatal situations such as the possibility of encountering Hmong rebels (anti-communists who had turned mostly to banditry). At times, up to five armed guards accompanied us, especially in the Kasi area north of Vang Viang in Vientiane Province, but also in Siang Khuang Province. With an arsenal of Russian Kalashnikovs, vests full of hand grenades, and flip-flops on their feet, our guards were well armed. Fortunately, they never had to use their weapons, which dangled from tree limbs as they watched us with amused interest while we dug in streambeds. To them, it appeared that we were merely playing with sand in buckets, like children. We never did encounter any terrorists, so I never took this threat seriously. Guerrilla warfare is a fact of life in much of the Lao countryside, so perhaps I was just naive.

Fieldwork and the Lao Spirit World

The spirit world was always present during fieldwork. Spirits supposedly loomed everywhere in the forest, and I was perplexed to learn that they were normally considered bad spirits. To me, the forest spirits seemed benign and beautiful, but everyone else, especially in Siang Khuang Province, feared the spirits, which had to be ritually appeased. I slowly learned the reason: many people, both from Laos and Vietnam, had been killed in Siang Khuang during the Vietnam War, so naturally many spirits were of Vietnamese origin. Local villagers worried because they could not understand the spirits that spoke Vietnamese, and the spirits were understandably disoriented and unhappy. Passing certain areas in the forest required adding leaves or flowers to huge piles of votive debris slowly amassed from other passersby "or the spirits will be angry." Naturally, we always complied.

My Buddhist colleagues carefully avoided spirit "altars" and "gates," which were commonly located in the forest and at village entrances, especially in Attapue Province. I was curious about the significance of these spirit structures, but my colleagues did not want to explain. "Those spirits are bad," I heard them mutter, which left me with a regrettable gap in my spiritual education. Some of the Lao Thoeng groups, especially the Lave in Attapue Province, were said to put spells on people, to be experts at extracting poisonous substances from plants, and to poison you if they did not like you. We usually made wide detours around those villages, but I wondered what medicinal knowledge might go to waste if those tribes adopt a lowland Lao lifestyle and lose their knowledge of forest plants.

Spirits also lived in caves in Khammuan Province, which has a spectacular karst landscape, providing an abundance of caves, caverns, and disappearing streams. Some of the caves are connected by natural tunnel systems extending right through the mountains; cool drafts travel through these tunnels and emanate from the cave openings. The locals, however, divine only spirits in these drafts—spirits that have to be appeased. Thus, we did not venture into any of those caves, despite all the interesting geological features they contain. Instead, we once had lunch in a small restaurant located at the entrance to one of those tunnel systems; evidently the owner ignored the spirits. This was one of the few times during fieldwork when the spirits appeased *us* for a change—by providing natural air conditioning!

I adopted the delightful habit of offering food for the forest spirits anytime we had lunch in the bush. I learned that one could plead with the forest spirits. Prior to eating lunch, we placed a morsel of food on a leaf or log with an incantation to the forest spirits to be good to us, to give us luck, or "to let me win the national lottery," as one of my colleagues used to say. This votive food offering also kept the biting, red ants at bay. I often watched the ants carry off the spirit food, little by little, while letting us eat our lunch in peace.

Countryside Lunch Stops

Fieldwork also provided moments of rest and contemplation. One of my favorite ways to escape the sizzling heat was to eat lunch under a big shade tree humming with the shrill din of hundreds of cicadas. A lunch of sticky rice, hot chili peppers, pickled vegetables, ginger-marinated and dried beef strips, and sun-warmed mangoes, all served on banana leaves, constituted the best possible prelude to a relaxing noon nap, ants permitting. Big shade trees in inhabited areas were hard to find, however, and commonly the only remnant of large trees and the forest that once existed were huge roots and buttresses dumped

along roadways for later pickup and transport to Thailand. There, the roots would be carved into bizarre-looking furniture. End of forest.

Because the lunch trees typically were small, we had to scrunch prudently into the meager shade, listening only to the rattling of leaves in the hot wind and the croaking of frogs in nearby rice paddies. When the rain poured and we could not find a tree for protection, we took shelter in a reed hut in a rice paddy, and we ate lunch while listening to the patter of raindrops on the straw roof—another good prelude to a nap.

Vestiges of large, drowned trees still remained in Nam Ngum Lake in Vientiane Province, a large lake behind a dam constructed in 1992 as part of the first major hydroelectric project in Laos. Dark and silent, barren trunks and branches rose above the glassy surface of the lake, a ghostly skeleton of a forest once green and teeming with wildlife. The hot, humid air created rippling mirages above the mirror-like, leaden surface of the lake, and the dead trees seemingly came alive, flexing their branches. Even these pitiful remnants were not left alone. They were logged by boat.

I perceived Nam Ngum Lake to be a natural lake because of the natural-appearing shores and the eerie silence, punctuated only by the occasional splash of a fish or the sound of the engine on a small fishing pirogue. When we conducted fieldwork along the shore, fishing and swimming were always on our minds. Hand-carved fishing poles did not yield any catch, though, much to my colleagues' disappointment. Moreover, the act of swimming was too complicated, because Lao tradition did not permit us simply to throw off our clothes and jump in. Instead, we could only submerge with all our clothes on because we were in mixed company. Although the cool water continued to beckon, we were content merely to sit and gaze over the lake while eating our sticky rice (not having forgotten to feed the spirits), all of us immersed in our own thoughts.

My Friends in the Hills

When traveling by myself, I could be more selective in my destinations. I was drawn to northernmost Laos, partly because it was outside our field areas, and also because it was relatively easy to traverse by bus, truck, riverboat, and on foot.

I commonly followed the same route for each trip, and I could therefore monitor the changes that occurred as the years passed. Elaborate, Thai-style houses shot up everywhere like mushrooms, replacing thatched huts from past eras. Houses and *wats* got new coats of paint, and streets were widened and paved. Cows and goats disappeared from open grassy areas, which were transformed into manicured lawns. Old, majestic trees were cut down and replaced by saplings, which quickly died for lack of care. Whole markets and bus stations were relocated to the outskirts of towns. I did not realize then that many of the scenes I had photographed in Luang Phrabang, Udomsai, Phongsali, and other places would disappear after a few years.

I came in contact with many interesting people, and I found the remote hill tribes to be the most intriguing. Initially, I met tribal people in chance encounters; then I took some time and effort to get to know them as friends. Some of these tribes are becoming less remote. They are undergoing tumultuous changes as new roads are constructed near their villages, and "progress" invades even these last strongholds of a rich past. The results are predictable: "I do not want to wear traditional dress anymore," exclaimed fourteen-year-old Sanjeun in 2003. An Akha girl of the Nuqui subgroup from a village near Bun Nuea in western Phongsali Province, Sanjeun was bothered that "the Lao Lum make fun of me, and foreigners stare." Sanjeun glanced indifferently at the glass beads I had brought her, the kind used in traditional dress. On past visits, she had excitedly and breathlessly run off to show my present to her friends, and had immediately begun threading the beads into new strands for her cap. On my last visit in 2003, Sanjeun wore a nondescript blouse, a sarong, and her long hair in a ponytail. This is contrary to the tradition of unmarried Nuqui girls, who normally have their hair cut short to fit the exact shape of their coin-decorated, embroidered skullcaps.

Sadly, Sanjeun's reluctance to carry on tradition will probably become more common among young tribal people, as newly built roads encroach on their formerly remote villages, and as inhabitants of entire villages are coerced into moving to the lowlands to prevent shifting cultivation. Outsiders, who will now have easy access, no doubt will unintentionally or intentionally infringe upon these mountain tribes' traditions and spiritual values. I have watched Sanjeun's village slowly lose its soul. Soon it will be merely a colorless cluster of huts, wood-shingled roofs replaced by rusting metal. Nothing seems to be replacing its disappearing culture except for a sense of resignation. During my latest visit, I was informed that "the Thai" are funding the construction of a village school where children will be taught to read and write for the first time and not in their own language, but in Lao. Any influx of outsiders into this village will hasten the eradication of the last vestiges of its culture.

"She *will* wear traditional dress again when she marries," insisted Sanjeun's mother, Konu, as if this had become a bitter issue between them. Perhaps so, but Sanjeun's declaration made me realize the importance of recording these endangered people on film. For eight years I regularly visited Sanjeun's village, photographing her family and the other inhabitants, at first with their reluctant consent ("Is a camera dangerous?"), but later with their eager cooperation. I always brought the photos from the previous trip, and they were much appreciated. Included in this book are some of those photos, a few showing Sanjeun in traditional garb, perhaps for the last time.

Another village I visited is in a far more remote area of northern Phongsali Province, with a battalion of attack leeches lying in wait en route. Its remoteness may protect this isolated village from the ongoing ravages of development. Other than the few travel companions I brought along, I was the first and only foreigner to have visited this village. Compared to the fading existence of Sanjeun's village, this nearly inaccessible village was full of dignified people who were proud of their heritage and traditions. They grew all their own food, and every time I visited I was treated to a rich menu of mountain rice, a variety of green vegetables, homemade bean curd, soups, pork, chicken, and forest products such as mushrooms, bamboo shoots, and ferns. I also got to savor such delicacies as fermented rice, poached pig's brain, freshly cut sugar cane, and corn that had been ground, sweetened, and baked in green leaves.

I named this Akha village of the Nuqui subgroup "Atuma's village" after Atuma, a girl I photographed on numerous visits. Atuma's village bustled with activity, and no one sat still. Unpretentiously proud women ruled the grass huts. Girls like Atuma were still elated to receive hard-to-come-by glass beads, which they would string together into strands for their caps, already thick with beads and silver. The hospitality in this village was extraordinary. After years of visits, it was difficult for me to pass a hut without being invited in for tea. The most remarkable characteristics of this village were the innocence of its people, their apparent belief that the outside world was good, their wonderment at some gadget I had brought along for the trip, and their astonishment at some simple magical trick performed by a travel companion. I am horrified that the culture of these vulnerable, good-hearted people is being threatened by extinction. When will they be coerced into taking the first step on the path toward "progress"? That time will invariably come, even to this remote village. Will this start a downward spiral toward loss of identity, culture, and traditions? Will the proud maidens here share Sanjeun's fate? Or will they prevail, by integrating modern conveniences into their own way of life and beliefs? With the gumption shown by the people in Atuma's village, their culture has a chance at survival.

Between 1995 and 2003, I also visited a third village, near the little trading town of Mueang Khua, where the Pala people have been able to integrate some modern conveniences into their traditional way of life. Although pigs and water buffaloes still roamed the narrow lanes, most of the old, thatch-roofed huts had been replaced by wooden houses with metal roofs and colorfully painted eaves in a style I had not seen elsewhere in Laos. To produce electricity, which was used only on special occasions, men carried 100 kg generators uphill for six hours. Villagers now had the option of playing gongs in live performances, or listening to music on battery-powered radios. A teacher from the lowlands lived reluctantly in this village and taught in an elementary school mostly for boys, yet numerous children with nothing else to do followed me wherever I went. In this village, the women continued to wear traditional clothing, but they behaved differently from their counterparts in the other two villages I visited. Here, women ran with exuberance rather than merely walking with dignity. They ordered men around and told them what to do—the men didn't seem to mind—perhaps because the men consumed too much *lao lao* (a strong rice wine), smoked too much opium, and thus needed some guidance.

Guarding the Past while Heading toward the Future

The countryside in Laos is dotted with villages—clusters of stilt huts around which water buffaloes graze and children play. A small morning market, a one-monk *wat*, and a few little shops complete a village. Women and men sit under the huts and weave, chat, or rest on strategically placed wooden pallets from which they watch village activities.

Laos has few "real" towns as seen in the eyes of a foreigner. Vientiane is one such town, however, that was my home, and still feels like home—its dusty, hot street scenes seared into memory while I bicycled to work: stilt huts competing for space with embassies and candy-colored *wats*; unexpected mansions and veritable palaces with gold-plated gates found along little-frequented back streets; lush gardens enveloping mansions inhabited by expatriates, every plant cultivated by hired gardeners; and vendors selling everything from nuts and bolts to mangoes and mangosteens. Vientiane received a bounty of foreign aid in the 1990s, but the boom has faded. Land Cruisers are fewer, replaced by swarms of Chinese-made motorcycles. Bicycling Lao women, in traditional *sin* and carrying colorful umbrellas in one hand as a shield against the sun, have nearly vanished, but their images linger like mirages in the midday heat.

The placid surface of the Mekong River flowing by Vientiane forms a mirror for reflecting picture-perfect, flaming sunsets, easily outperforming glitzy Thailand on the other side. New beer stalls and restaurants have shot up by the hundreds after the old and established ones were torn down. Tourists barely see the Mekong because *Beer Lao* is excellent. The Mekong is just there, brown and quiet, keeping its distance—deceptively so, because it breaches its banks with impunity when it must.

Luang Phrabang is another "real" town, well known among tourists. Because of its designation as a UNESCO World Heritage Site, old architectural landmarks have been preserved. Shop houses in Mediterranean hues pale in the shadows of the many spectacular golden *wats*. Awed tourists ogle at all the gold and marvel at the traffic-

free streets. Because of Luang Phrabang's World Heritage designation, a French colonial house cannot be torn down clandestinely on a dark night as has been done, for example, in Vientiane. World Heritage status is a valiant attempt to keep Luang Phrabang frozen in time. In reality, however, this is a hopeless task because something is lost every time new paint is applied over the faded charm of yesterday.

Since the influx of tourists, in the 1990s, Luang Phrabang has undergone dramatic changes. The first "banana pancake" meal, a curious staple of backpackers, appeared in the early 1990s. The hunger for pancakes has since diminished as the menu has expanded. A myriad of little restaurants compete for tourists' attention and serve everything from fruit shakes to hamburgers. Although tourists fill these restaurants, the locals still patronize the early-morning noodle stalls. Parts of Luang Phrabang have been yuppified, but other parts are timeless and tranquil, with inhabitants sitting at tiny tables outside their front doors, eating noodle soup and chatting. Tourists and vendors establish rapport as tourist money fills the coffers of silver merchants and Hmong "needlework ladies" alike. Monks still walk in single file at dawn, with votive bowls in hand, and old ladies fill these bowls with the best sticky rice in Laos. Life goes on as before, and yet not.

The Mekong River is different in Luang Phrabang, closer somehow, flowing through the Lao homeland. Normally dark and mute, the forest across the river from Luang Phrabang becomes silvery and ethereal on bright, moonlit nights. At other times, the river can be ominous, transporting forests of downed trees in powerful eddies of swirling debris. Yet, during any day, children fling themselves into the brown, glittering water and shriek with laughter, heedless of hidden dangers in the murky depths.

Along the Mekong and in mountainous enclaves as well, Laos displays a colorful and poignant past that lingers innocently today. The Mekong continues to be a vital artery, connecting people in many provinces. As "progress" tightens its grip, however, the Mekong will probably flow toward irrelevance: it is too slow to keep up with the pace of change, fewer boats will ply the river, children will bathe at home in new bathtubs, and fishing will become too inconvenient. On the other hand, the natural environment may recover as long gone forests along its banks reclaim territory.

Irrevocably, Laos has opened the door on tomorrow, and there is no turning back. The future of Laos brims with possibilities—as long as the forest spirits are kept appeased.

NOTES

Lao place-names have been romanized in the text and map to conform to a consistent system (Ed.).

1 Martin Stuart-Fox and Mary Kooyman, *Historical Dictionary of Laos* (Asian Historical Dictionaries: 6, 1992), xxv.

2 Ibid.

3 Tom Butcher and Dawn Ellis, *Laos* (London: Pallas Athene, 1993), 39.

4 Joe Cummings, *Laos* (Victoria, Australia: Lonely Planet Publications Pty Ltd, 2002), 16.

5 Butcher and Ellis, 44.

6 "The World Factbook," Central Intelligence Agency, January 13, 2011, https://www.cia.gov/library/publications/the-world-factbook/geos/la.html.

7 Laurent Chazée, *The Peoples of Laos, Rural and Ethnic Diversities* (Bangkok: White Lotus Press, 1999), 6.

8 These numbers vary from source to source, with a range of about 56–66 percent Lao Lum, 24–34 percent Lao Thoeng, and 9–10 percent Lao Sung.

9 Chazée, 6.

10 Chazée, 4.

11 Before the Indochina wars, more than sixty different groups were identified. Inconsistent definitions of what constitutes an ethnic group versus an ethnic subgroup caused these discrepancies, and confusion persists. Presently, experts from different countries use different classifications methods. Moreover, detailed ethnographic information about many groups is lacking, and the future will surely bring further revisions. The information in this book is based on current, but sometimes, conflicting sources.

12 Chazée, 1.

13 Stuart Chape, *Biodiversity Conservation, Protected Areas and the Development Imperative in Lao PDR: Forging the Links* (Bangkok, DYNA Print Ltd., 1996), 6.

14 The Ethnologue, http://www.ethnologue.com/show_country.asp?name.

15 David P. Bradley, *Proto-Loloish*, Scandinavian Institute of Asian Studies Monograph Series 39 (London and Malmo: Curzon Press, 1979).

16 David P. Bradley, *East and South East Asia*, in *Atlas of the World's Languages*, R. E. Asher and C. Moseley, eds. (Routledge: London, 2007), 157–197; cited in M. Paul Lewis, ed., *Ethnologue: Languages of the World*, 16th ed. (Dallas, Tex.: SIL International, 2009). Online version: http://www.ethnologue.com/.

17 Paul and Elaine Lewis, *Peoples of the Golden Triangle* (London: Thames and Hudson, 1984), 102.

18 M. Paul Lewis, ed., *Ethnologue: Languages of the World*, 16th ed. (Dallas, Tex.: SIL International, 2009). Online version: http://www.ethnologue.com/. Hmong statistic cited in Paul Hattaway, *Operation China* (Pasadena: William Carey Library, 2000). Lanten statistic cited in Laurent Chazee, *Atlas des ethnies et des sous-ethnies du Laos* (Bangkok: L. Chazee, 1995).

19 Lewis, *Peoples*, 102.

20 "Internal Religious Freedom Report 2002," *U.S. Department of State*, 7 October 2002, http://www.state.gov/g/drl/rls/irf/2002/13878.htm.

21 H. Deydier, *Introduction to the Knowledge of Laos,* trans. Dorothy Crawford (Saigon: Imprimerie Française d'Outre-Mer, 1952).

22 Source: "Global Forest Resource Assessment 2010, Main report. FAO Forestry paper 163, Food and Agriculture Organization of the United Nations, Rome 2010." http://www.fao.org/forestry/fra/fra2010/en/

23 Fred Thurlow, "For Laos, it's steady as she goes," *Asia Times Online*, March 16, 2001, http://www.atimes.com/se-asia/CC16Ae02.html.

24 Matthew Pennington, "Laos' hill tribes resist dropping old habits," *The Associated Press on the Web*, January 9, 2001, http://www.canoe.ca/CNEWSFeatures0101/09_laos-ap.html.

25 M. Dufumier, *Les projets de développement agricole* (París: CTA-Karthala, 1996).

26 Pennington, "Laos' hill tribes."

27 Jean-Christophe Vié, Craig Hilton-Taylor and Simon N. Stuart, eds., *Wildlife in a Changing World: An Analysis of the 2008 IUCN Red List of Threatened Species™* (Gland, Switzerland: IUCN, 2009), 127, http://iucn.org/about/work/programmes/species/red_list/review/.

28 Hanneke Nooren and Gordon Claridge, *Wildlife Trade in Laos: The End of the Game* (Nederlands Comité voor IUCN, 2001).

29 Klaus Berkmüller-Sangthong and Vongphet Southammakoth-Vene, *Protected Area System Planning Management in Lao PDR. Status Report to mid-1995* (Forest Resource Sub-Programme, IUCN, 1995), i.

30 N. M. Kemp, N. Dilger, N. Burgess, and Chu Van Dung, "The Saola *Pseudoryx nghetinhensis* in Vietnam: New Information on Distribution and Habitat Preferences and Conservation Needs," *Oryx*, 31(1) (1997): 37–45.

31 James R. Chamberlain, "Indigenous People and Hydropower Development: A Case Study in the use of Ethnologistic Analysis in Environmental Assessment," *Signposts to Asia and the Pacific*, Australia Centre for Independent Journalism, November 10, 1996, http://www.signposts.uts.edu.au/articles/Laos/Indigenous_People/366.html.

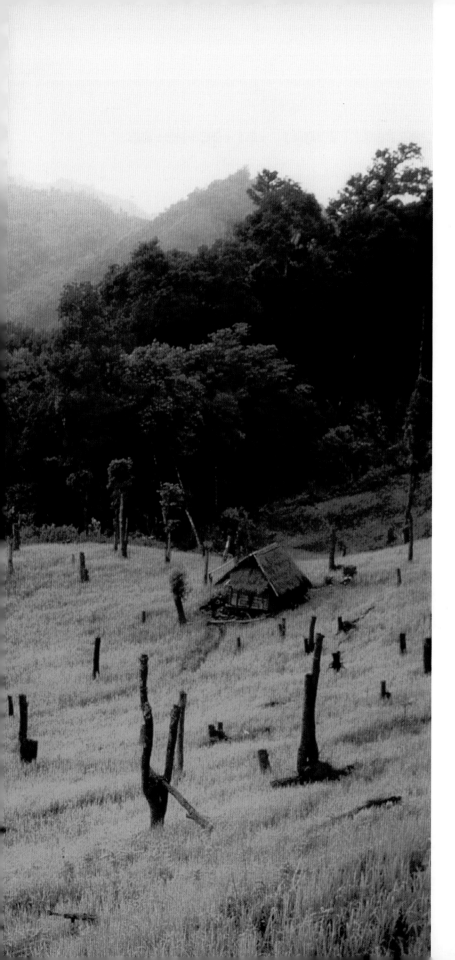

NORTHERN PHONGSALI PROVINCE

THIS IS A VIEW from the trail to Atuma's Akha village in Phongsali Province. After a five-hour uphill hike on steep, muddy trails through leaf-littered forests crawling with leeches and thick with saw-blade grass, I emerged to this vista of a luminous green field of mountain rice. Once I passed this particular clearing made by swidden cultivation and walked for another two hours up even steeper hills, I arrived at Atuma's village located at the very peak of the range.

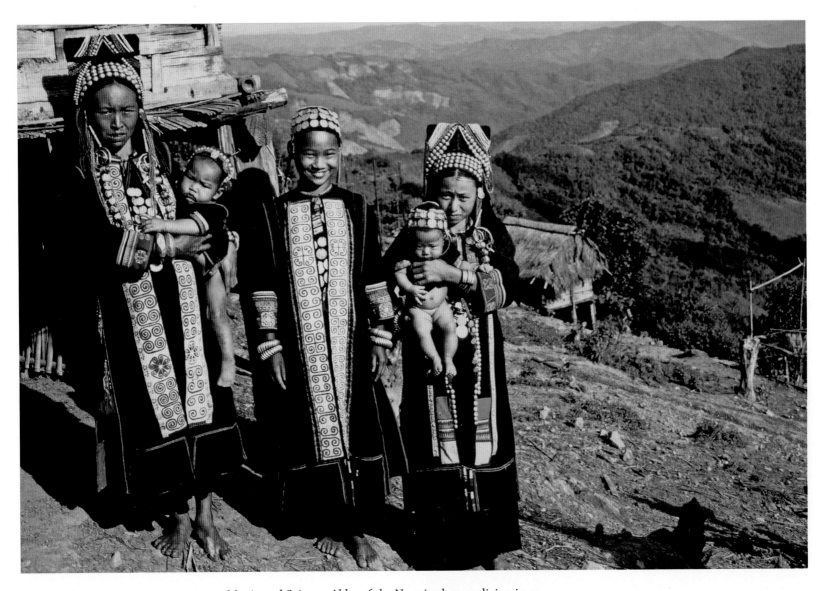

ATUMA AND HER SISTERS-IN-LAW Manjo and Saju are Akha of the Nuqui subgroup living in a remote village in northern Phongsali, here referred to as "Atuma's village." In this mountaintop photo session, they proudly show off their finest embroidered robes. Atuma stands in the middle wearing the head cap of an unmarried woman. Manjo, holding Nadja, stands to Atuma's left, and Saju, stands to Atuma's right, holding her baby. Women spend all their extra time embroidering their robes and headgear and the clothes of their babies. The clothes in the photo are worn for festivities and for visiting Phongsali. For everyday activities, the women often wear older, worn, and less elaborately embroidered clothes.

During my first visit to Atuma's village, all the women were frightened of my camera. They did not know what it was, and I had to let them look through the viewfinder to convince them that it was not some sort of weapon. Only after I brought back photos of them on a second visit did they understand the process and more or less happily line themselves up for this photo.

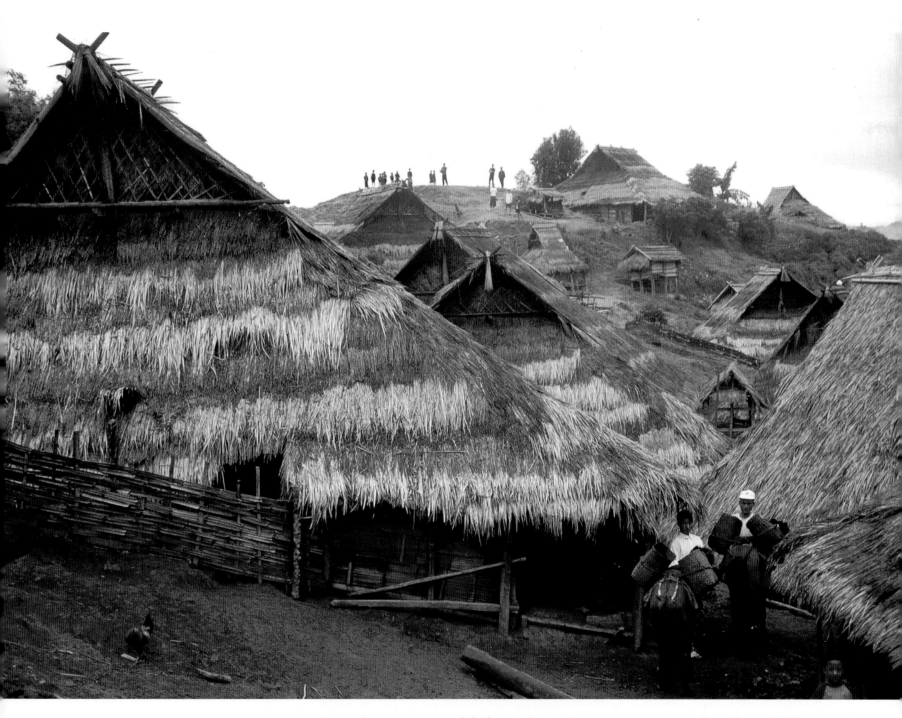

ATUMA'S VILLAGE is neatly laid out at the top of a mountain range in northern Phongsali. Wherever I went, male spectators, especially young boys, watched my every move as here, from afar. Friends of Atuma's family load horses to prepare for a trip to the river far below. Since I had planned to leave with them, they stuffed my small pack in one of the baskets on the packhorses, and off we went, half running downhill on muddy trails in a record time of three hours.

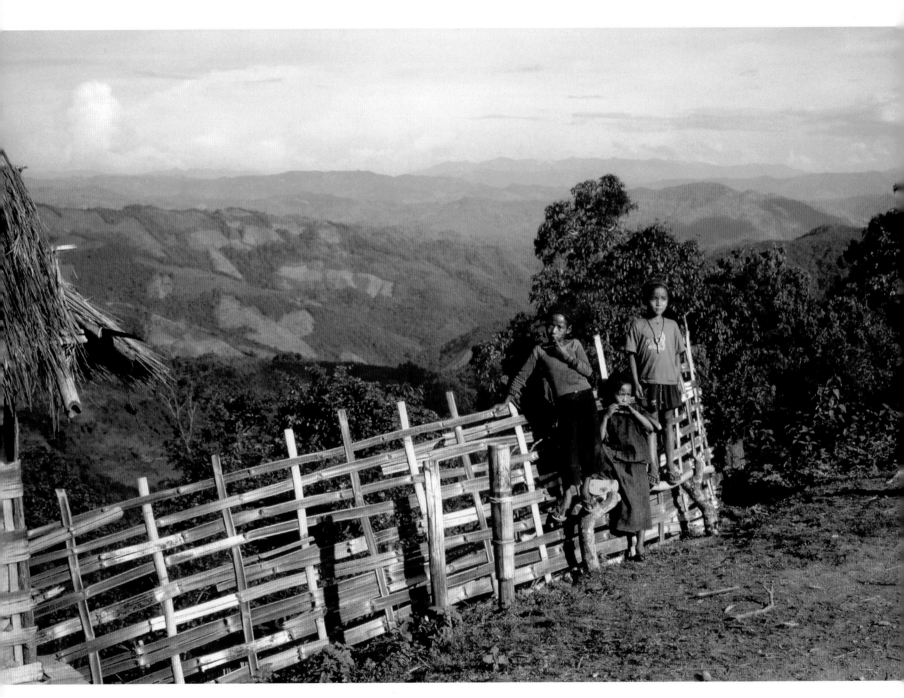

The boys who follow me around perch on a fence made of spliced bamboo. Many boys and men no longer wear traditional clothing, but few boys are caught without slingshots in their possession (one is hanging around the neck of the boy on the right). They are surprisingly skillful at using these as weapons; this is not merely a game, but a deadly serious attempt to add small animals such as squirrels and birds to the dinner table.

THE VILLAGE PERCHES MAGNIFICENTLY
on a mountain ridge, and the view is often
breathtaking. At night, only the moon and stars
illuminate the landscape and turn the valley
clouds an ethereal silvery gray. Dusk and dawn
are marked by spectacular, fiery displays as the
sun's rays emerge from a hazy horizon.

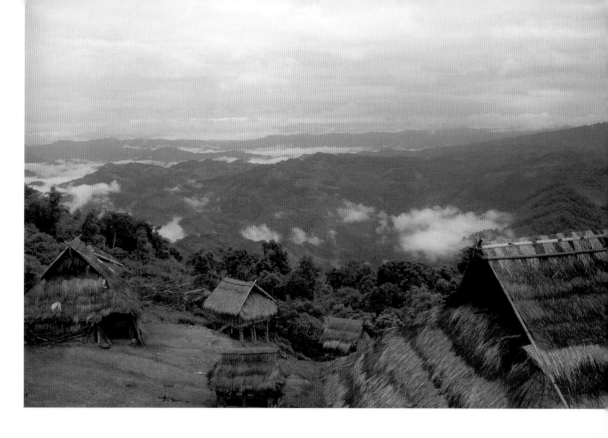

CATTLE REST in the early morning, as if waiting
for the mist to clear and widen their view of the
world. In the distance, a small rice granary stands
on stilts.

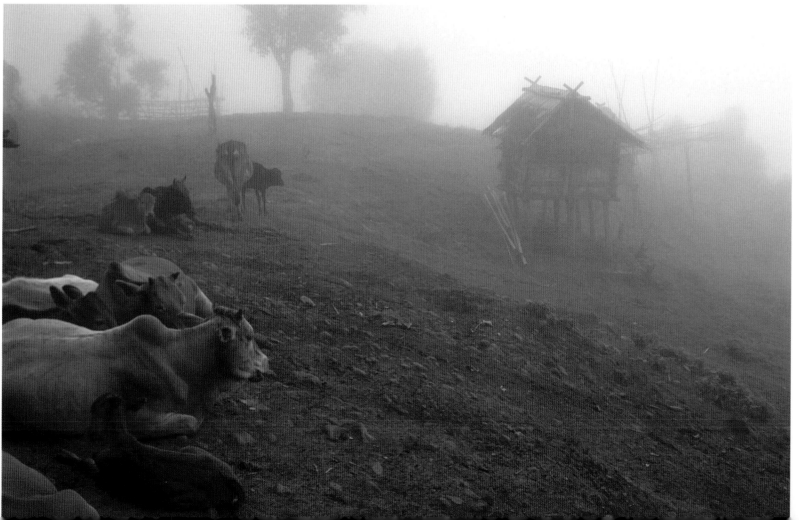

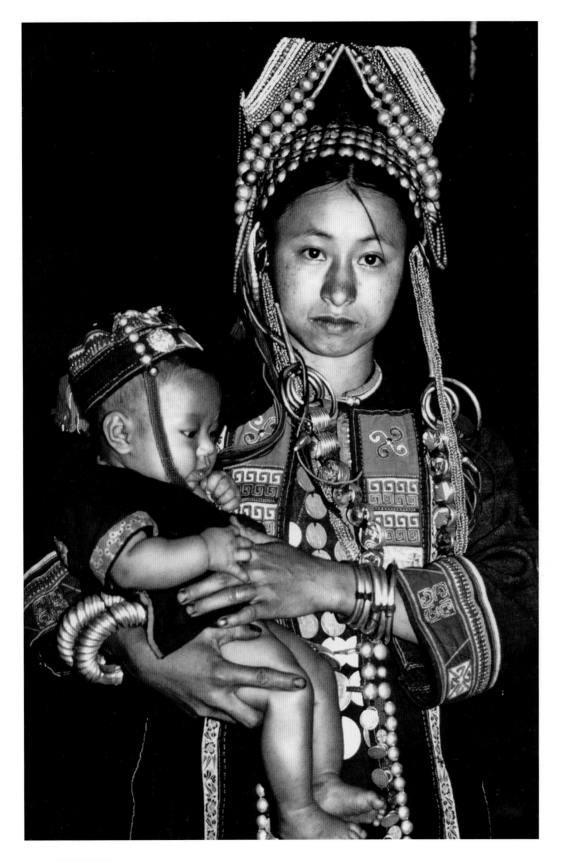

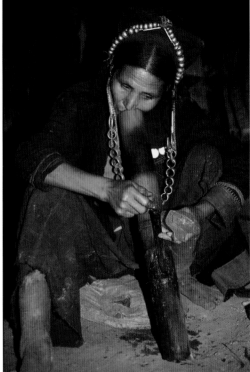

A WOMAN SMOKES a bamboo water pipe, which is an unusual sight in Atuma's village, where mostly men smoke. This is the preferred method of smoking tobacco here and in many other villages in Laos. The pipe is passed around the room, and everyone inhales deeply. Smoke is cooled when it is drawn through water at the bottom of the tube. Bamboo water pipes, ready to be smoked, have also been stashed at resting places along the trail leading to this village. Thus, a traveler does not need to carry a cumbersome pipe.

MANJO POSES WITH HER BABY, Nadja. Manjo's nails are blue from indigo dye extracted from the plant *Indigofera tinctoria*, which is used to color the handwoven material used for clothing. The plant is soaked in water, lime is added, and the mixture is kneaded into a paste by hand. Later, the paste is diluted with water to produce the desired color intensity. Women then dip textiles in the diluted mixture. It is a messy job, usually done on a raised platform out of reach of animals and small children. The colored cloth is hung to dry on racks along the platform.

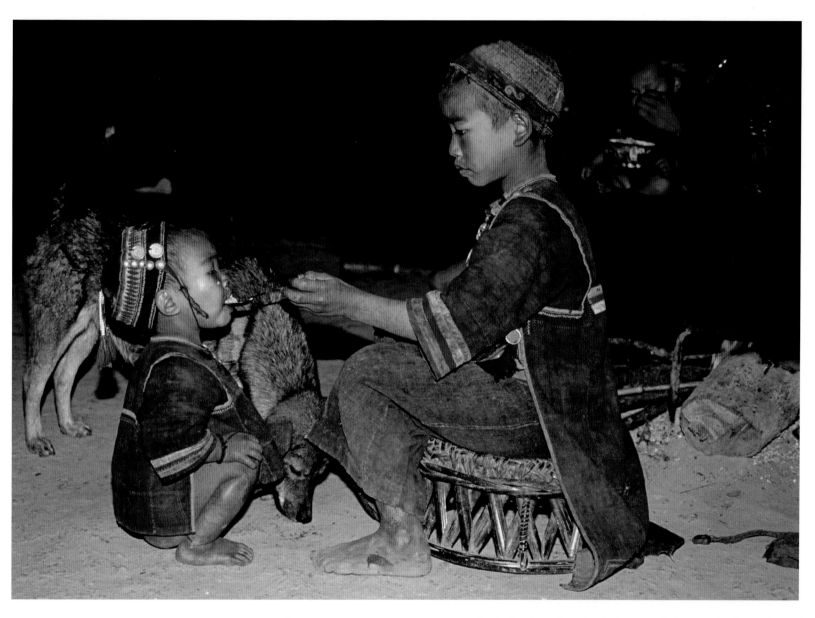

Mjaso feeds steamed rice to her baby sister Sa, who insists on sitting on the floor. One of the house dogs makes sure nothing goes to waste. As usual, older siblings—especially girls—help take care of younger siblings. Mjaso assumed her aunt Atuma's role in the family by helping with everything after Atuma married and moved to the village of her husband, as is customary.

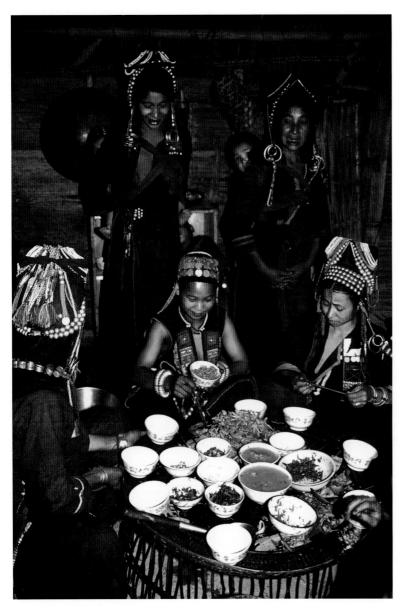

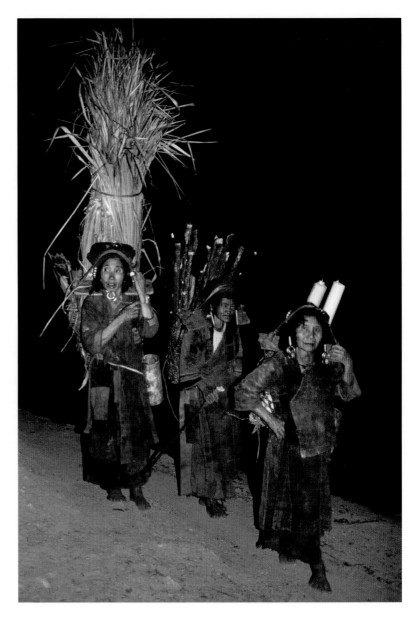

DINNER WITH ATUMA'S FAMILY included bamboo soup, homemade bean curd, steamed fresh ferns from the forest, cold fermented rice, and a whole cooked pig's brain. Steamed rice —not "sticky rice," the norm in the lowlands—was served from baskets placed around the table. Relatives and female friends crowded the hut to have a look at me. Although I was invited to sit with the men, who ate first at a separate table, I preferred to sit with the women, who ate after the men, because neither the women nor I drink *lao lao*, a strong rice wine. I could then avoid having to drink with every bite of food, which is customary for men at the slightest celebratory occasion!

THREE ELDERLY WOMEN dressed in their oldest clothes return from a hard day's work in the fields. As in other Lao ethnic villages I visited, women do most of the work, and always without wearing shoes. Here they are carrying grasses and reeds for patching roofs, bamboo segments to be made into water canisters, and of course, firewood. Women seem always to work in the company of other women and, thus, they can chat and gossip through their backbreaking labor.

No one in Atuma's village is ever without a task, except, perhaps, the ubiquitous opium smokers. Atuma feeds rice and scrambled eggs to Nadja, her baby niece. Atuma is constantly busy helping with everything from cooking, cleaning, and hulling rice to caring for infants and animals.

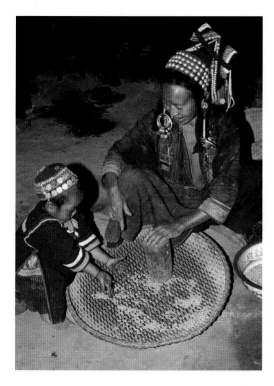

Sa thinks she is helping her mother, Saju, crush corn on a tray of woven reeds. Saju is more amused than grateful at Sa's attempts. Sa will soon be able to follow her mother's instructions, however, at which time her help will be indispensable to the family.

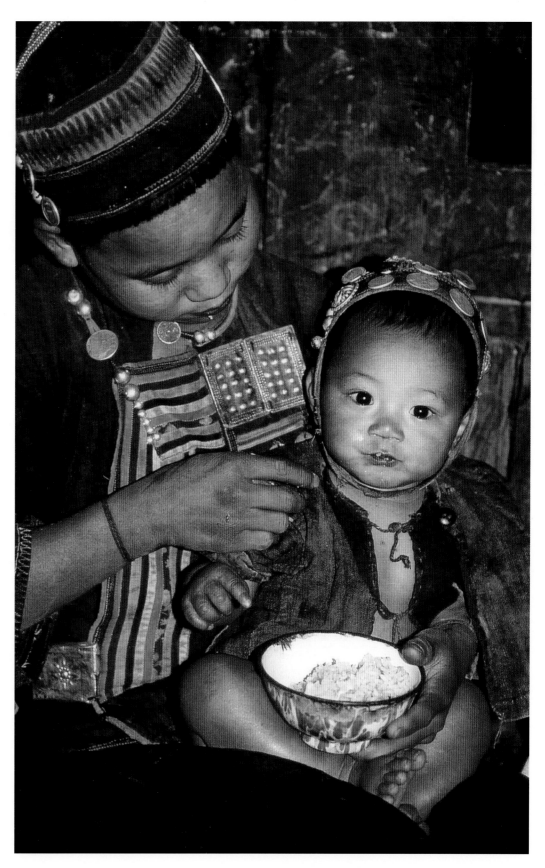

A LATE AFTERNOON THUNDERSTORM rolls in over Atuma's village. During the day, one thunderstorm after another may pass at a safe distance creating dark curtains of rain and wonderful light shows. The scenery, often magnificent, is ever changing throughout the day. The villagers are always perplexed at my interest in the view, which to them is just a perennial backdrop.

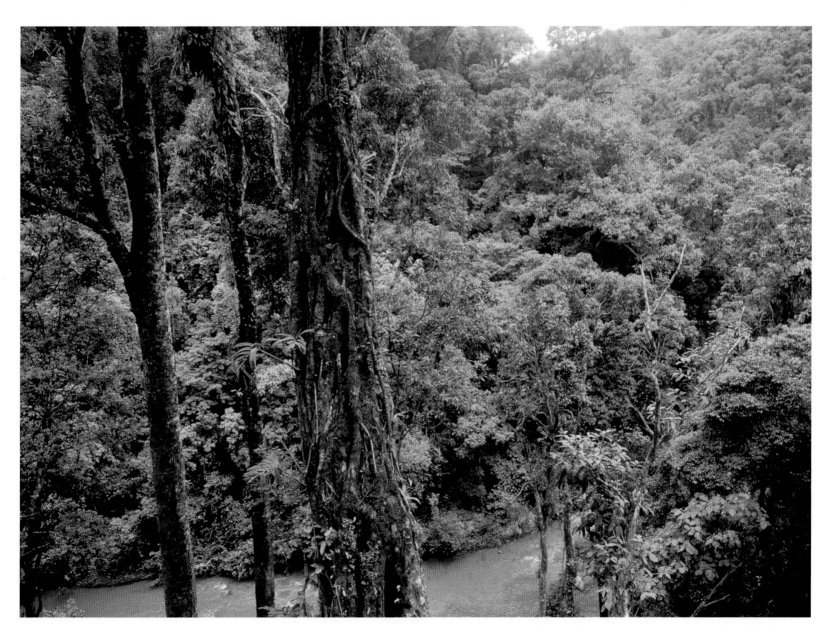

WESTERN PHONGSALI PROVINCE

THE FOREST STANDS TALL as I approach Sanjeun's village in western Phongsali. A step-like cattle gate marks the entrance to the village, and the forest beyond is relatively untouched. Inside the gate, I hear clear, beautiful, nearly ethereal songs coming from two woodcutters singing to each other across a steep river gorge. They ceased their singing only when they spotted me. Now, a new road allows lowland villagers to come up and cut down the trees, leaving large clearings in their tracks. The songs have stopped.

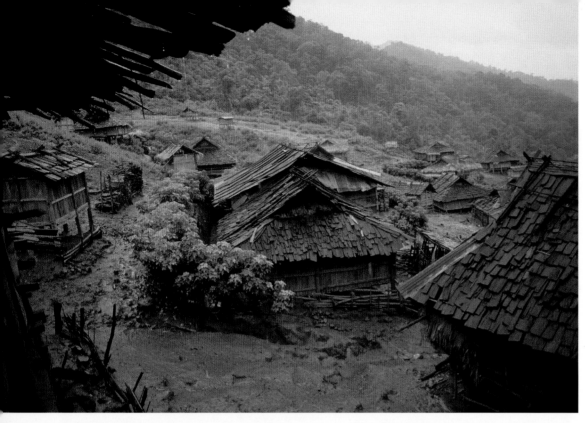

IT IS RAINING, and water drips from the shingles as I take pictures of Sanjeun's village from her little second-floor veranda. Afternoon thunderstorms are common, and the rain turns the village grounds into slippery, liquid mud. Everyone runs inside; even chickens and pigs seek shelter. A total lack of windows makes it gloomy and dark inside, but the children run around shrieking and playing, as if they can see in the dark.

SANJEUN (*right*) and her little cousin play on a trail near the village, happily unaware that eight years into the future this trail will become a road which will bring an end to their traditional way of life.

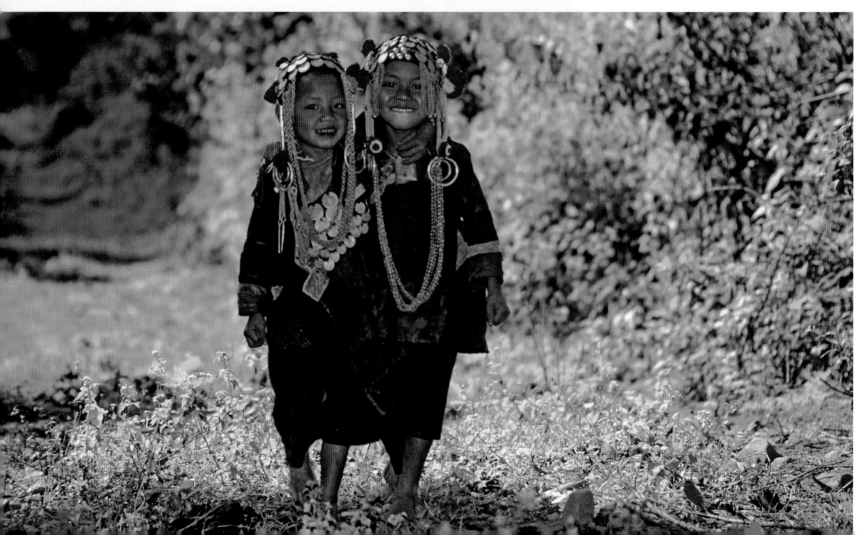

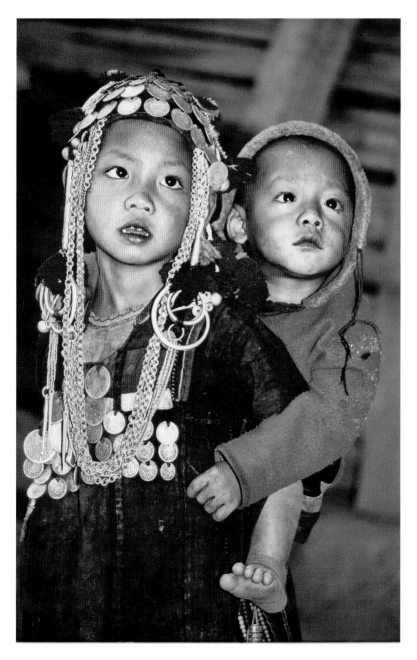

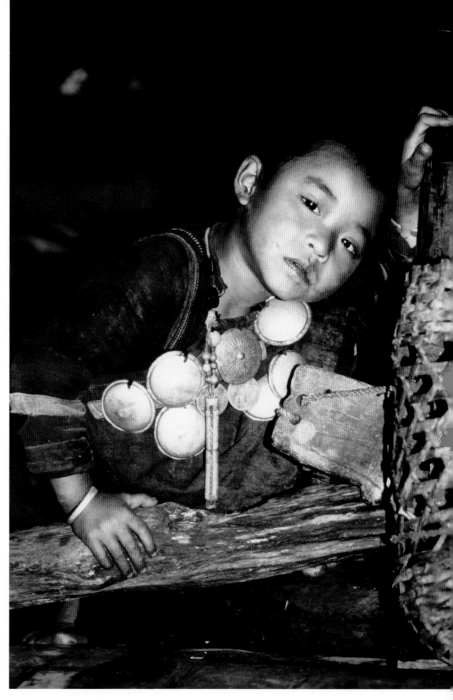

SANJEUN'S COUSIN CARRIES HER BROTHER on her back. They live in the house next to Sanjeun and her family. Young girls always help take care of their younger siblings while their mothers work in the fields. Five- to six-year-old girls, commonly carrying their baby siblings on their backs, act as perfect substitute mothers, even while silently enduring colds, fevers, and infections. Seldom have I seen a child in this village without a cold.

THIS LITTLE AKHA NUQUI GIRL takes a rest before carrying a basket with water-filled bamboo tubes back to the village. Invariably, in the hills and in the valleys, water is inconveniently downhill from the dwellings. Women and children use shoulder baskets to carry empty bamboo tubes downhill, sometimes for a long distance, and they carry the heavy, water-filled containers back uphill. The water source can be a clear spring but more commonly is a muddy pool. Once when I visited this village, the regular spring had dried up, and the entire village had moved closer to a flowing spring.

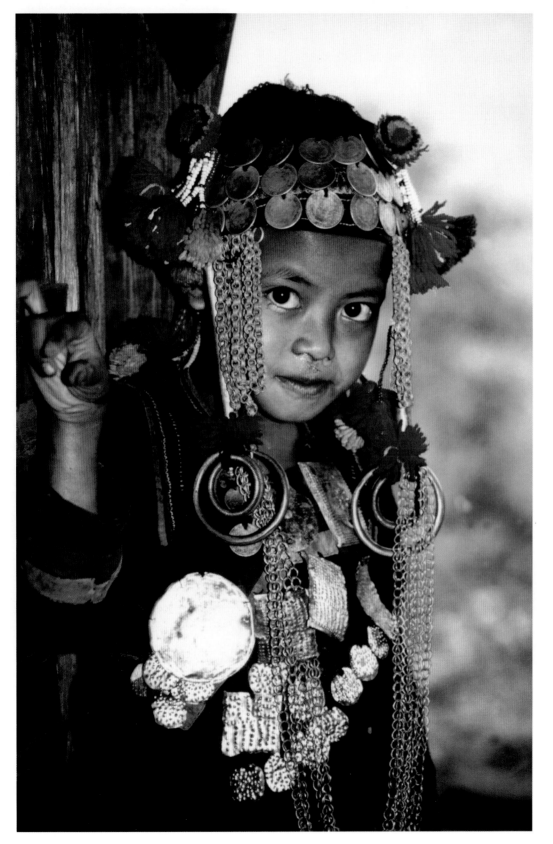

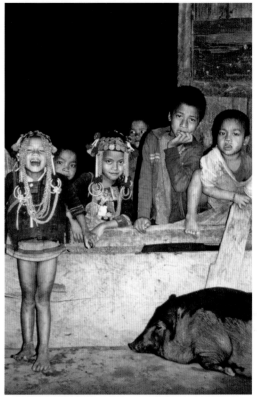

CHILDREN PLAY behind the round door opening to Sanjeun's house (Sanjeun is leaning over the threshold in the middle). This round door opening provides endless entertainment for these children, who clamber back and forth. The threshold also keeps water out during rainstorms. Pigs cannot breach it, although dogs can easily jump over. The village fowl are not supposed to cross this obstacle, but they do so anyway, and Konu (Sanjeun's mother) constantly chases them out of her house.

GROWING UP IN AKHA CULTURE without banks, six-year-old Sanjeun wears her bank account: a heavy wealth of silver coins, chains, and baubles made colorful by yarn pompons. At this age, she never removed her headgear even while playing and while helping her mother with household chores.

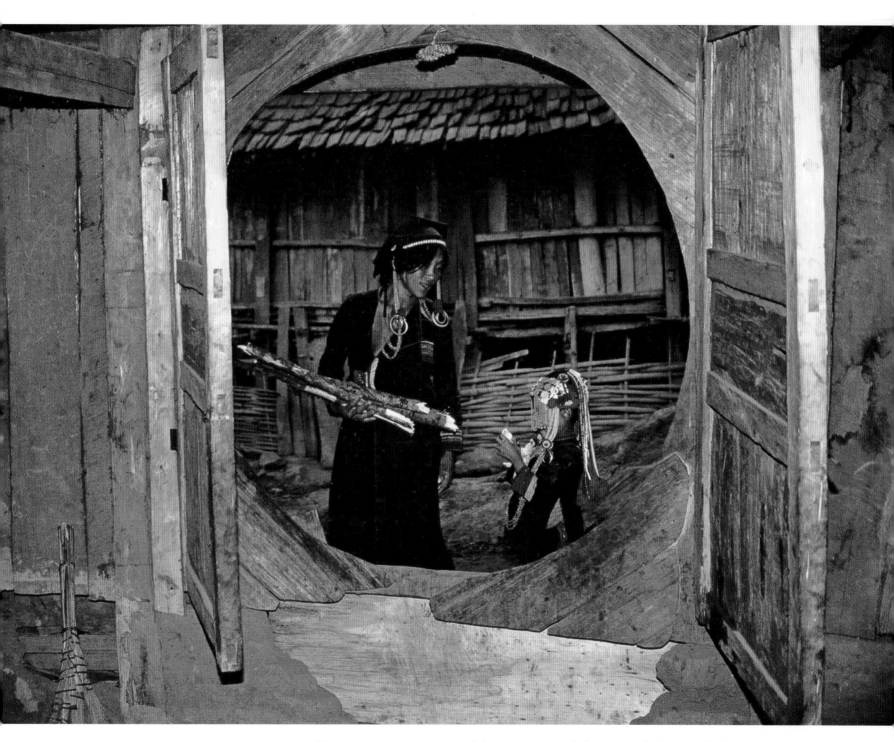

KONU GATHERS WOOD and Sanjeun wants to help as I watch from inside their house, which is the only house in the village with a round door opening. The threshold is high enough to keep out the pigs and chickens, but low enough to allow the older children to climb over and still keep in the smaller children. To Konu's great irritation, chickens constantly sneak into the kitchen area through the back of the house.

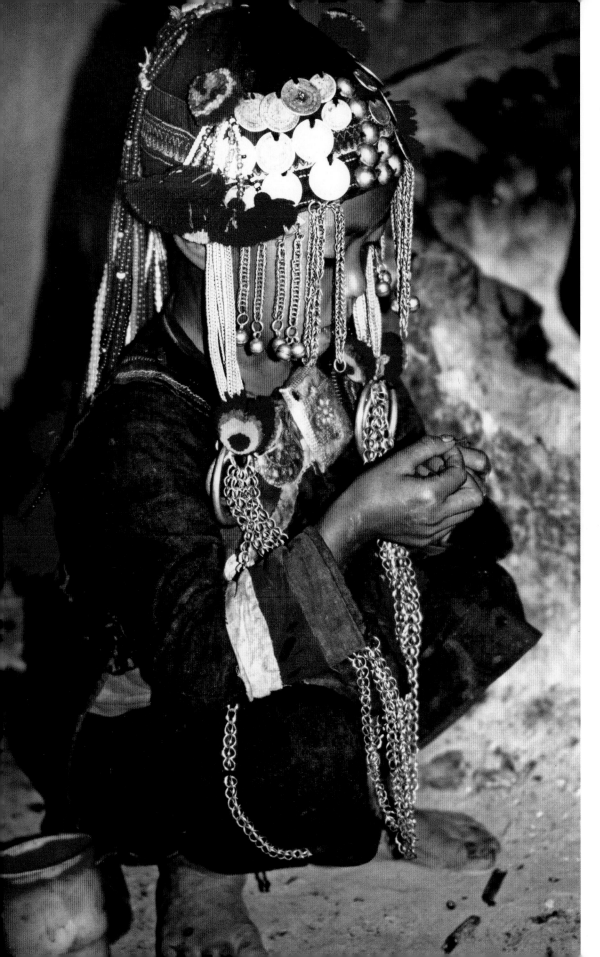

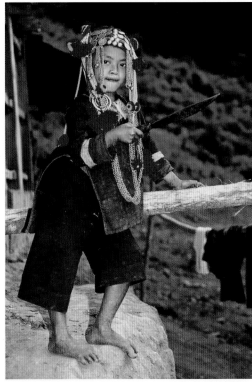

SANJEUN CHOPS AT A LOG with her machete, only because she has nothing else to do at the moment. In this village, children use knives both at work and play. Even small children can handle machetes quite skillfully, and babies are encouraged to play with them. I have seen small children, five or six years old, heading out to harvest plantain with machetes nearly as large as themselves. Sometimes there are accidents. I treated a child who cut her finger to the bone with antibiotic cream and a Band-Aid—a real novelty in Sanjeun's village, where wounds commonly become infected.

SANJEUN HELPS HER MOTHER peel garlic beside the cooking pit. She also helps fetch water, sweep the floor, pound the rice, and care for her younger brother. Even at this tender age, girls work more than they play. In contrast, boys congregate in groups and run around and play outside.

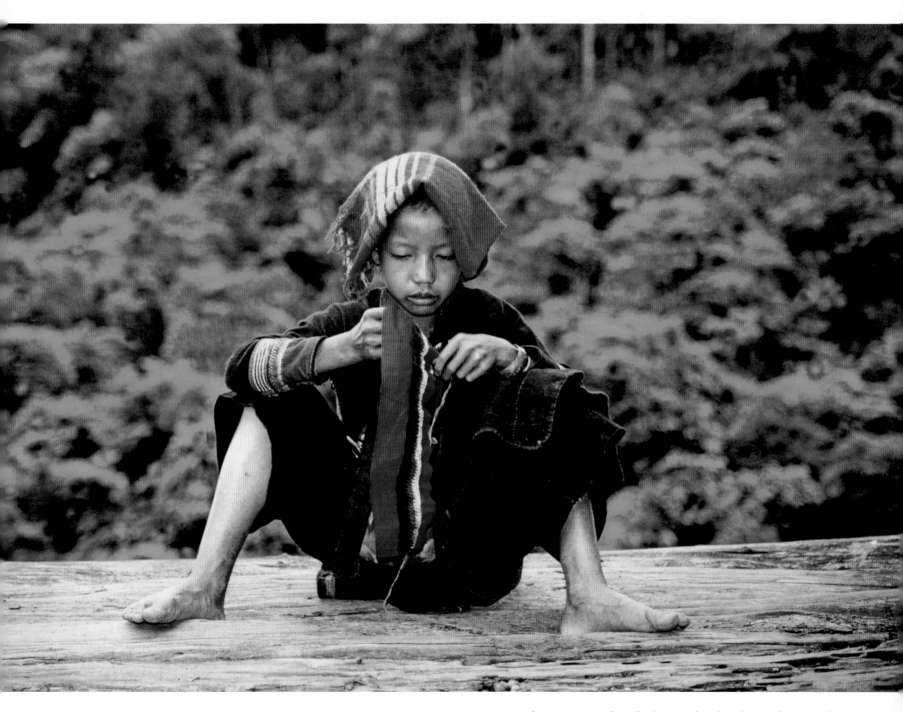

IN THE LATE AFTERNOON SUN, a girl sits on a wooden platform and embroiders a sleeve, with the forest as a backdrop. The platform is high enough that small children, pigs, goats, or chickens can't bother her. She has removed her headdress and replaced it with a scarf. She is so intent on her work that she never noticed that I took the picture.

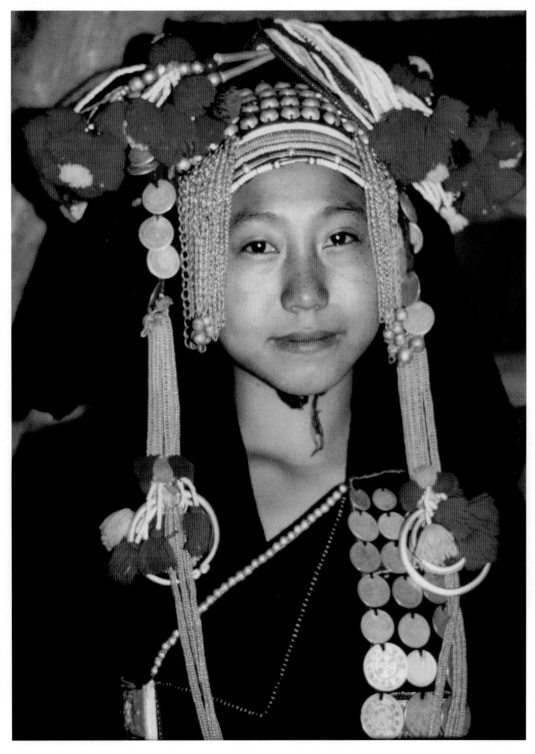

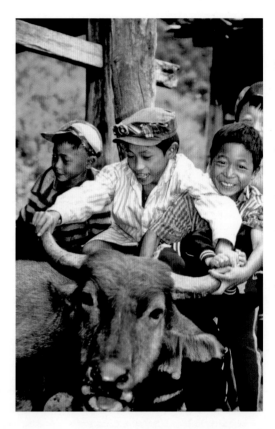

THE VILLAGE BOYS in Sanjeun's village in western Phongsali are never shy and happily welcome any photo opportunity. Here they tease a water buffalo for my benefit. The many children in this village appear to be completely unsupervised and rule over the pigs, dogs, chickens, and water buffaloes. These children are happily wild, noisy, caked with dirt, have runny noses, and some have extended bellies from malnourishment. Most have probably never seen a bath. Their parents often work in the fields during the days and bring only nursing infants along. Thus the older children have the run of the village. The elderly, who can no longer work in the fields, are in charge of the youngest children.

"SHE IS A GODDESS," whispered Michael, a young traveler I had invited to come along for this trip. Shortly after our arrival at Sanjeun's house, this girl entered, and Konu, Sanjeun's mother, proudly showed her off. The "goddess" joined other women and children in massaging our legs, as is customary when welcoming visitors who have walked long distances. My young travel companion was ecstatic.

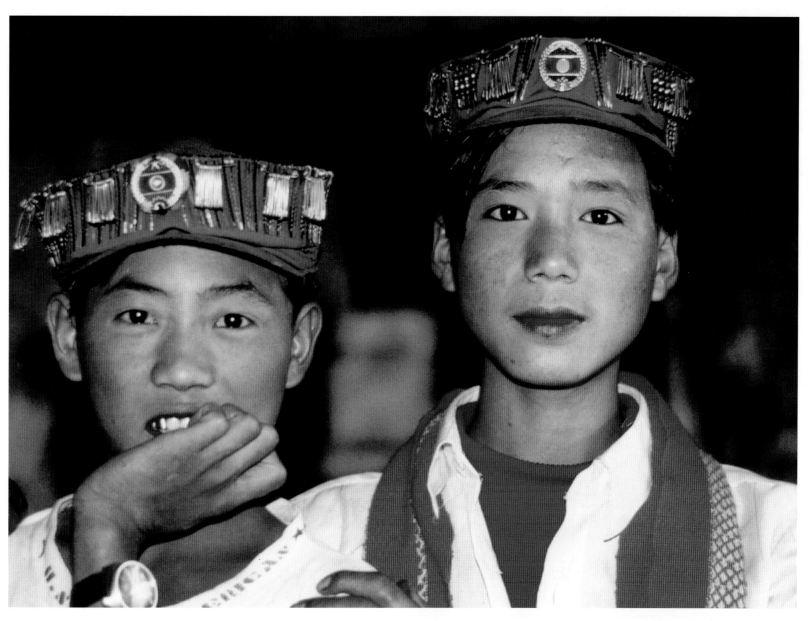

TWO YOUNG ELIGIBLE BACHELORS have ways of getting attention from the girls. With shiny rows of safety pins on their army caps, a touch of red color on their cheeks and lips, and colorful towels around their necks, how could any girl resist! The Chinese wristwatch is an empty shell with painted features that look real; I wonder what shrewd merchant took advantage of him.

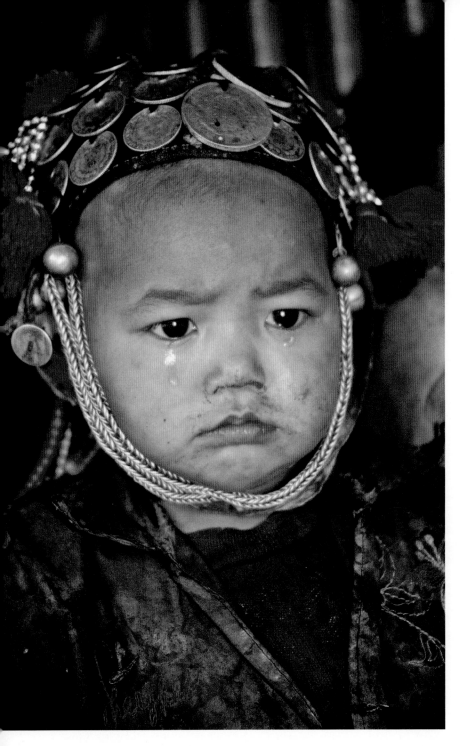

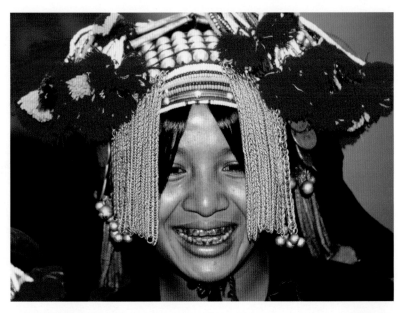

THIS UNMARRIED AKHA NUQUI GIRL has stained her teeth red with betel nut, a common practice among hilltribe women, who proudly show off their blood-red teeth. Unmarried and newly married women display colorful headdresses heavy with silver buttons and chains, multicolored yarn pompoms, and glass beads. These headdresses, sometimes covered with protective cloth, are worn while working in the rice fields and while cooking and cleaning. In fact, I never observed any married woman removing her headdress. Young girls occasionally replace their headdresses with colorful scarves. Many young women have now chosen a Lao Lum lifestyle, and, sadly, no longer wear their traditional dress.

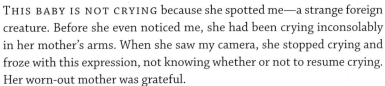

THIS BABY IS NOT CRYING because she spotted me—a strange foreign creature. Before she even noticed me, she had been crying inconsolably in her mother's arms. When she saw my camera, she stopped crying and froze with this expression, not knowing whether or not to resume crying. Her worn-out mother was grateful.

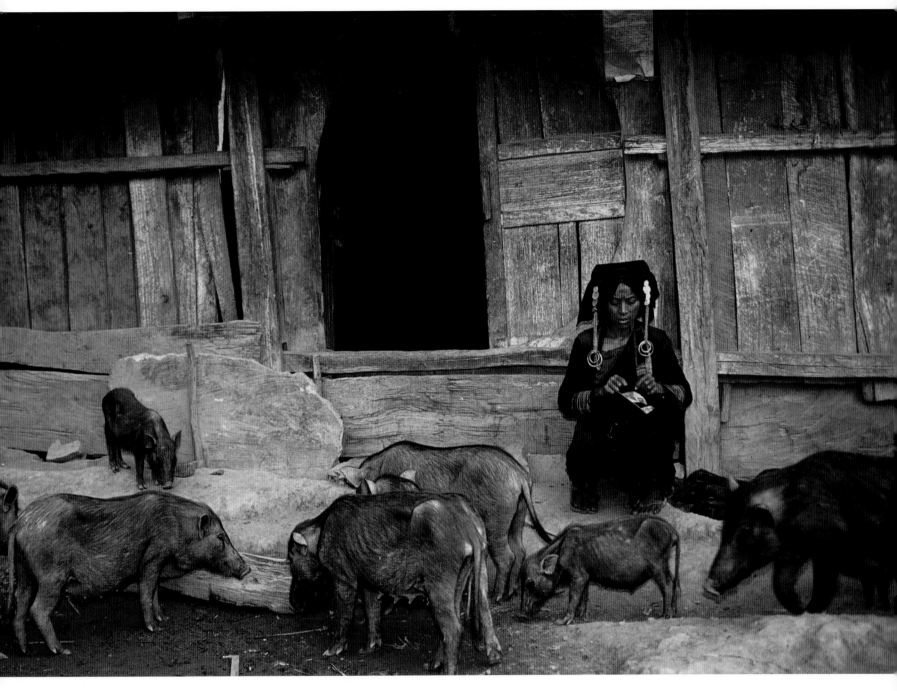

KONU MENDS CLOTHES OUTSIDE her round door opening while keeping an eye on her pigs. They are lean because she does not have enough food to feed all of them. In 2003, shortly after a road had been built nearby, this village became exposed to outsiders, who were quick to arrive. Representatives of Thai and Japanese organizations visited to donate pigs (including the pigs in this photo), a simple schoolhouse (not yet completed during my last visit in 2003), and motorized farming equipment. All these donations were in exchange for the villagers' agreeing not to cultivate opium. I have never seen opium grown or used by any of Konu's family members.

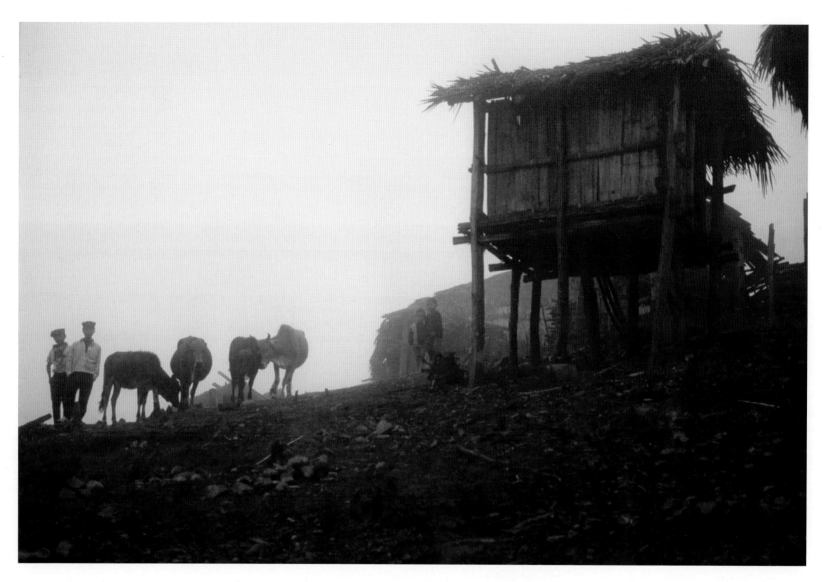

RICE GRANARIES AND LIVESTOCK appear through the dawn mist as I prepare to leave Sanjeun's village for the long walk back to Ban Bun Nuea, where I plan to catch a truck back to Phongsali before nightfall. Two young men (lower left) with army caps watch from a safe distance. I know the trail by heart, and the early morning walk through the forest will be refreshing.

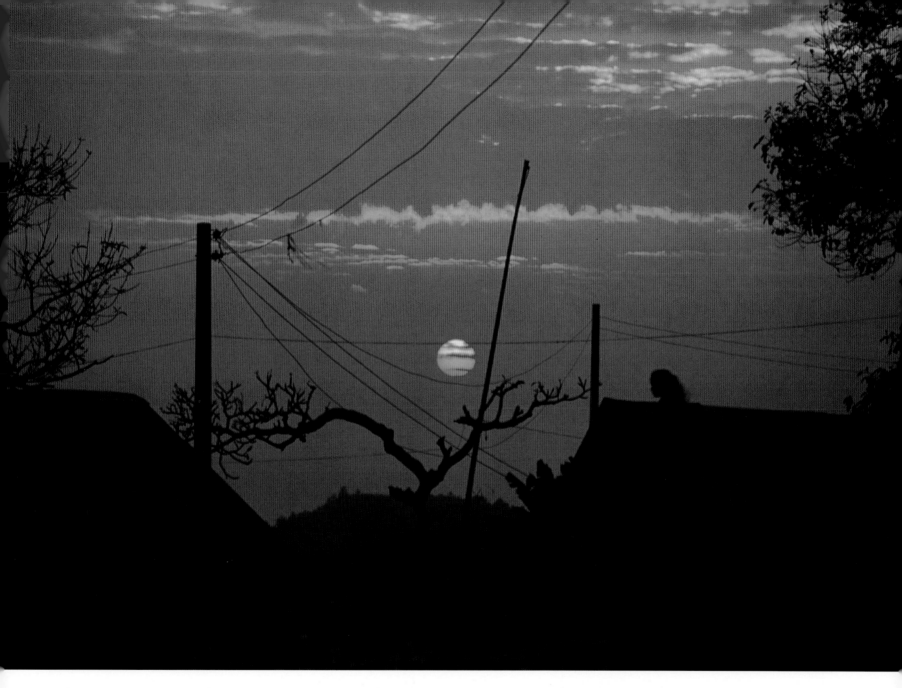

PHONGSALI TOWN

THE INTRODUCTION OF ELECTRICITY to Phongsali added power poles and a tangled web of power lines to the scenery at sunset. I knew electricity was coming to this little town when I saw concrete power poles lying beside the roads on previous visits. Although I have been accustomed to switching on lights since birth, I found the electrification of Phongsali to be an unsettling experience. Before electricity arrived, a Rembrandt-esque tranquility had prevailed, with single candles illuminating austere rooms and families singing and playing on home-made instruments. After electricity arrived, bluish fluorescent light replaced the yellow candlelight, and throngs of people massed in front of a few television sets blaring blurry Chinese programs in black and white. By 2003, individual families owned color televisions, and they have been introduced to Chinese soap operas—a fast journey to the era of new technology and a sedentary lifestyle.

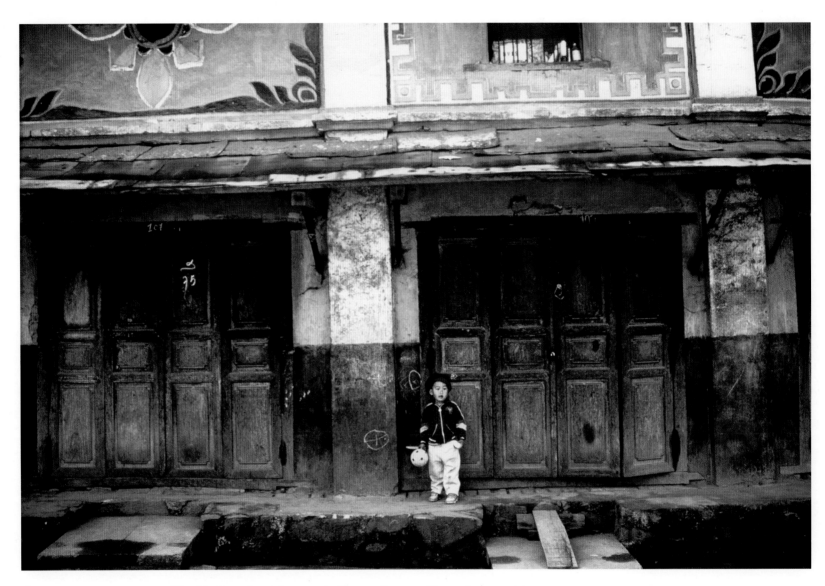

A QUAINT STREET SCENE like this from the main street in Phongsali town will soon be something of the past. In 2003, most dwellings along the main street had been repainted and refurbished. Houses like this used to serve as retail and noodle shops. All retail shops used to sell essentially the same wares, mostly imported from China. Now, many of these shops have moved to the new indoor market, and, except for an increase in parked motor vehicles, the main street is as quiet as it was when I first visited Phongsali ten years before.

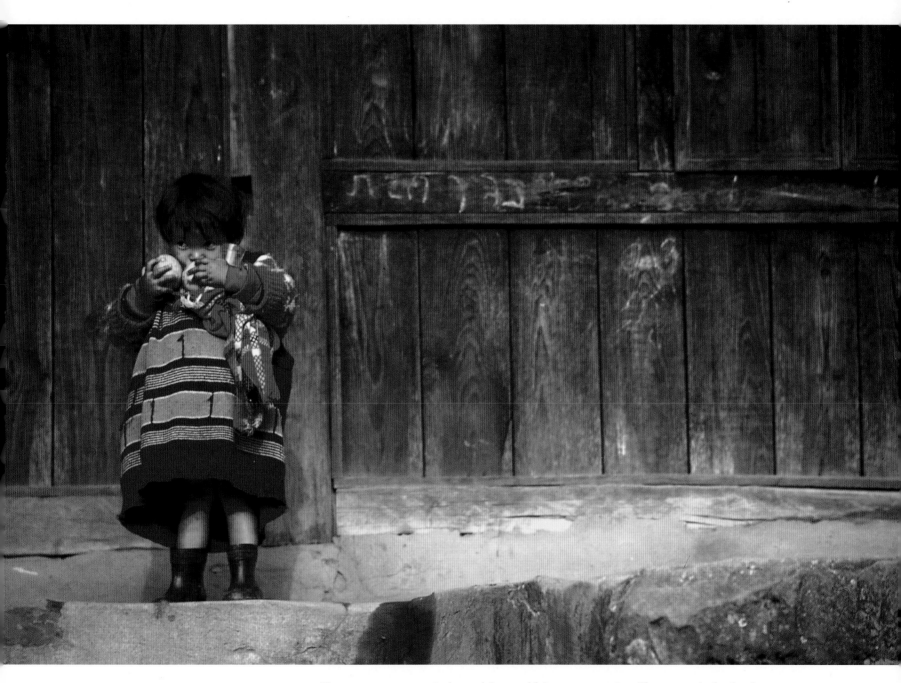

THIS LITTLE GIRL is dressed for a cold January morning. She protectively clutches two oranges she has received from someone, as if she is afraid she might lose them at any moment. She dutifully awaits her mother, who came to get her very soon.

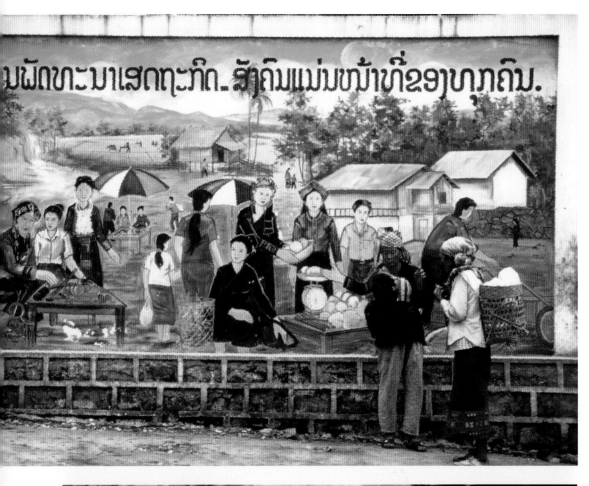

IN 1997, A NEW MURAL stating "Social and economic development is the duty of everyone" appeared below the old, elevated, outdoor market in Phongsali. Judging from the women depicted in the mural, this slogan was directed at women from a variety of ethnic groups, although hilltribe women are least likely to be there to read (or to be able to read) this slogan. In 1999, the old market was moved to a new indoor enclosure in the southern part of town. The concrete mural slab was still there in 2003, but all the paint has peeled off, and it stands mute and uninformative.

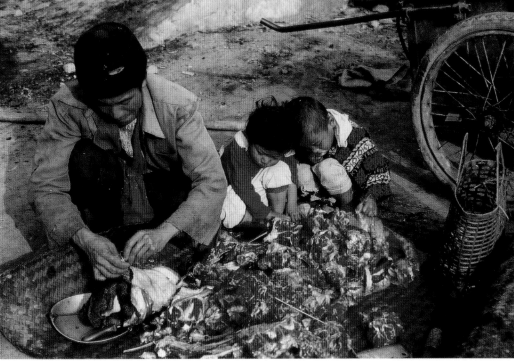

EARLY ON A CHILLY JANUARY MORNING, this man has slaughtered one of his buffaloes in the dark, as is customary in places without refrigeration. He displays the fresh meat below the old, elevated Phongsali outdoor market at seven in the morning, and all the meat is sold within two hours. His two children have no aversion to playing with the meat while huddling together for warmth. Meat is usually sold early in the morning; a cut of meat that appears appetising in the cool morning loses its appeal in the sweltering afternoon.

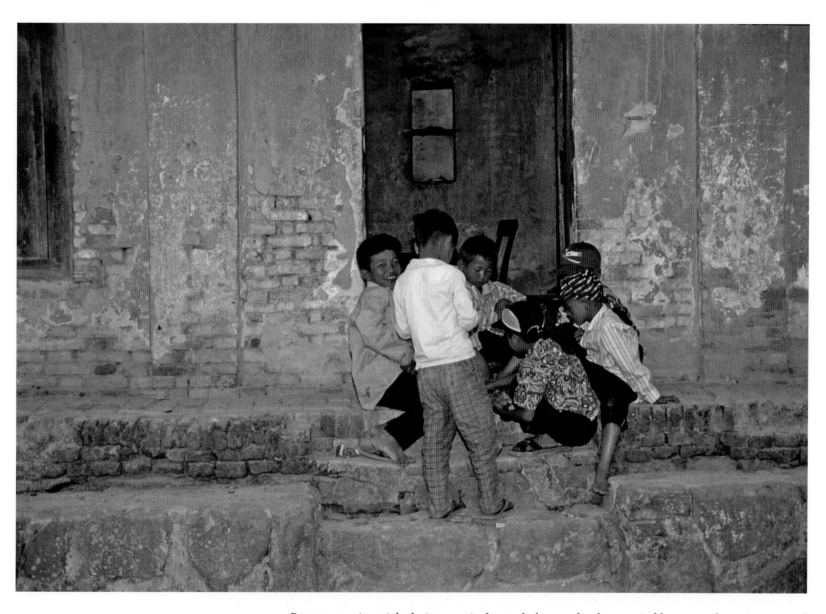

BOYS PLAY in a tight-knit group in front of what used to be a typical house on the main street of Phongsali town. Everywhere in Laos, boys play in similar groups, often sitting at a street corner, on a bench, by a storm drain, or as here, by a doorway. They are playing games or looking at some creature that is invisible to an outside observer.

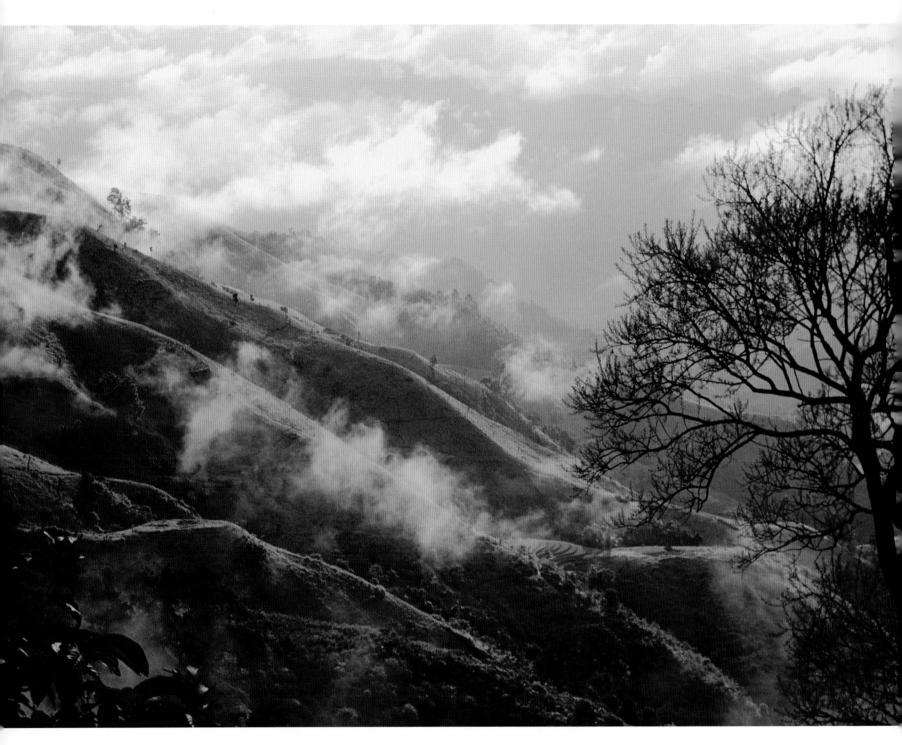

One magical aspect of Phongsali town is this mountain vista, which is only visible from a hidden edge of town. After walking along rutted lanes, past huts and shops, dodging pigs and chickens, a visitor reaches the outskirts of town. Suddenly, the confining narrow spaces of the town give way to this spectacular view of mountains peeking through mist in the wake of a late afternoon rainstorm.

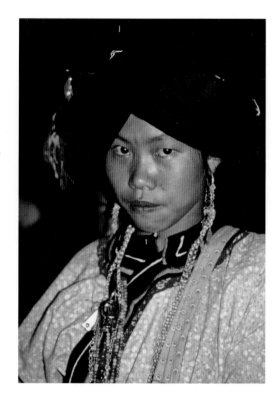

THIS WOMAN from the Ho ethnic group in the far north of Phongsali Province is in Phongsali town for shopping. It was getting dark, and I was sitting on a street corner watching the passersby when I spotted her. Admittedly, I did not ask for permission to take her photo, and she glared at me just as the camera clicked.

PHONGSALI TOWN ABRUPTLY ENDS in one corner where the houses are connected by narrow alleys. One of these alleys dramatically opens up to a spectacular valley with a trail leading out of town high up above the valley floor. Once on the trail, it is as if the town never existed, and a restful silence envelops the landscape. This tree was blossoming on a beautiful January afternoon along the trail.

LOCATED NEAR PHONGSALI HOTEL in Phongsali town, this house was ablaze with color in the orange glow of the afternoon sun. The next time I visited Phongsali it was "renovated" with gray cement walls. This is no longer a house anyone would notice and the blossoming hollyhock are gone.

SOUTHERN PHONGSALI PROVINCE

AS VIEWED FROM THE SUSPENSION BRIDGE spanning the Nam Phak, inhabitants of Mueang Khua take their evening bath in tranquil water gilded by the setting sun. The Nam Phak drains into the larger Nam Ou, a main artery between Mueang Khua and Luang Phrabang.

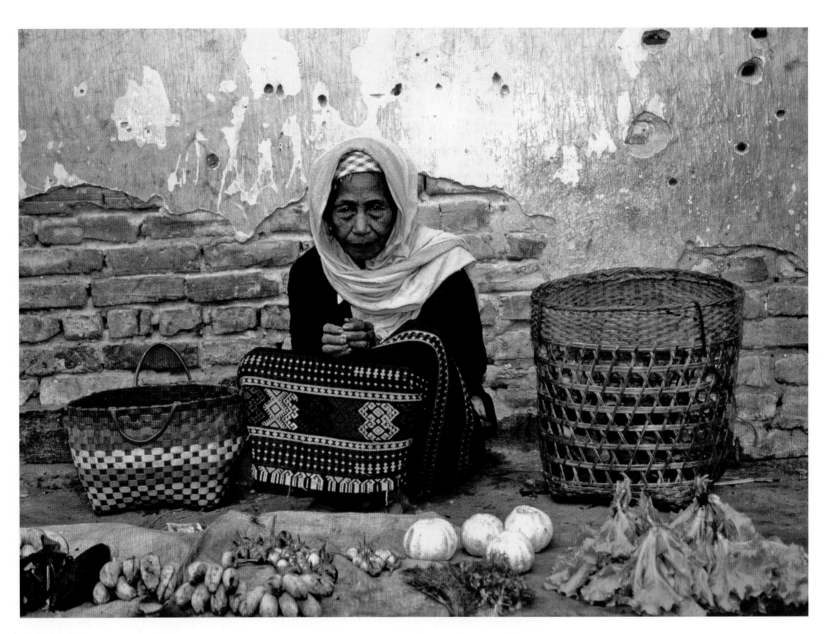

AN OLD WOMAN SELLS VEGETABLES at the old market in Mueang Khua, Phongsali Province. The wall behind her is bullet-riddled (according to the locals), a reminder of the Vietnam War. One can only imagine what took place here. This vegetable market has since been moved to a larger, indoor location. As in many other small towns, the new market is larger and combines food and retail wares. Two years after this photo was taken, I spotted this woman again, and I gave her a copy of the photo. She was overjoyed and wanted to give me every single vegetable she had for sale—for free!

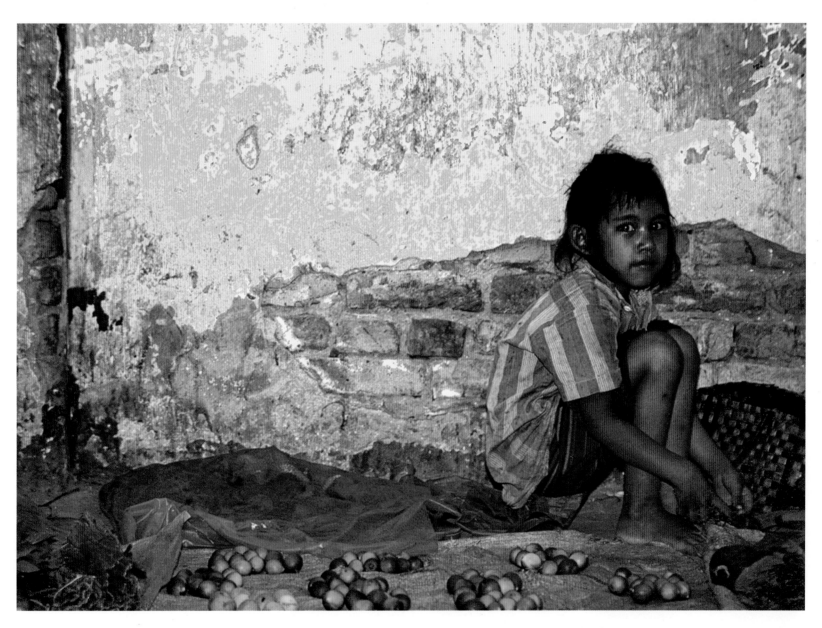

A LITTLE GIRL SELLS LIMES in the Mueang Khua market. Her mother, who probably worked nearby, came to check on her progress once, but this little girl did not leave her duties until the market closed. Her profit could not have been great, and I bought two limes in order to contribute something.

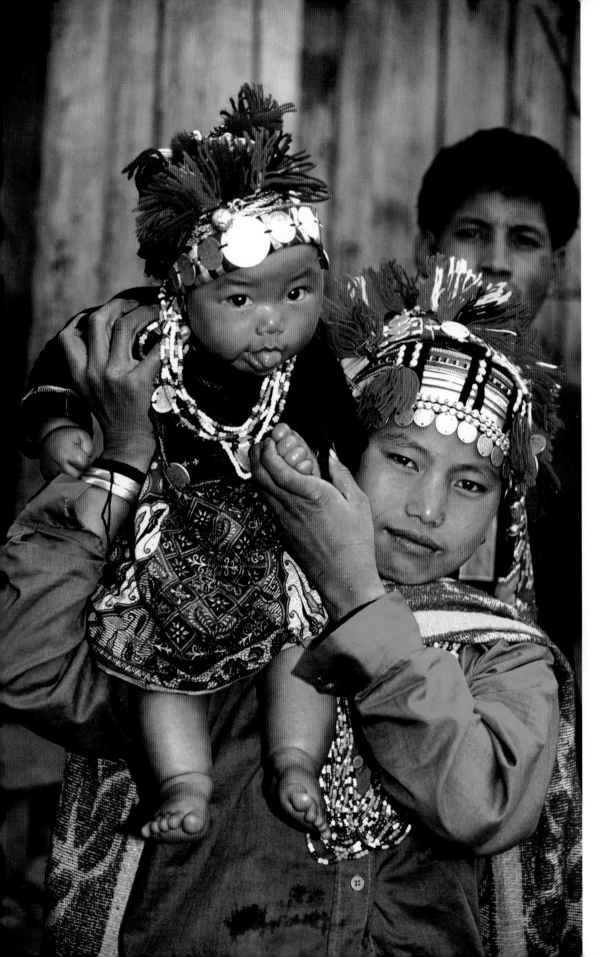

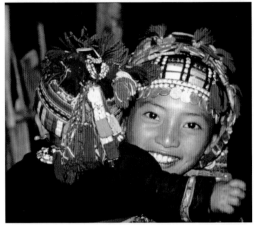

IN A VILLAGE within a day's walk from Mueang Khua, a smiling, unmarried Pala youth carries a baby girl. Both are dressed in identical ethnic clothing, with elaborate embroidered caps decorated with colorful yarn, glass beads, and silver coins. When mothers are busy, sisters, daughters, and unmarried female relatives are more than happy to care for babies.

THIS BABY is chubbier and healthier than most, so she was constantly being held up for display. Shortly after being weaned at two or three years of age, some children become malnourished, as indicated by swollen bellies, reddish hair, and spindly legs. Although the diet is protein deficient, I have never observed anything resembling true starvation.

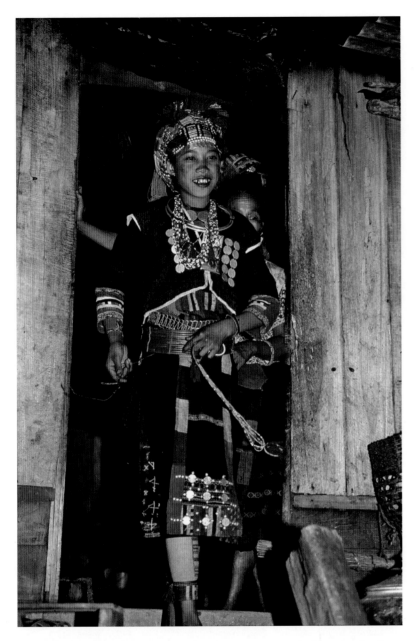

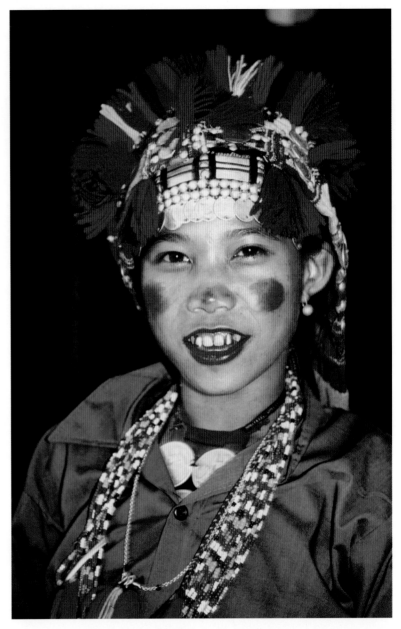

WEARING HER BEST CLOTHES and no protective clothing for the dust, this young Pala woman prepares for a gong performance on the occasion of my visit. The women in this village run around, laugh out loud, chase the men, and show no hesitation in ordering them around, in marked contrast to women from other tribal villages I have visited. Most Akha women are dignified, quiet, and proud, but also subservient to their men. Here, the men appear to be subservient to the women, but many men did not contribute to the daily tasks, spending their time instead smoking opium in their huts.

A YOUNG, UNMARRIED AKHA PALA GIRL shows off her colorful headgear. On festive occasions, red smudges are applied to the cheeks and nose, and it was a festive occasion merely because I was visiting. Green shirts must have been bought in bulk in Mueang Khua, because many of the young women wore identical green shirts over their tribal clothes when working in the field or kitchen, evidently to protect their elaborate and ornate tribal dress from dirt and dust.

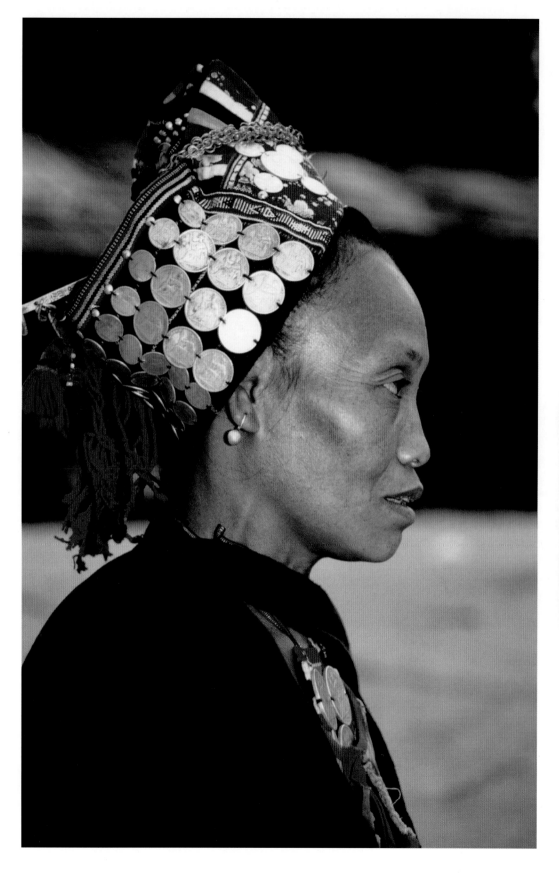

A MARRIED PALA WOMAN visiting Mueang Khua poses in her beautiful, coin-decorated headdress. The women commonly leave their mountain villages long before dawn and walk in the dark for hours to reach Mueang Khua (or other market towns), only to sell a few vegetables. Then, unless they have a friend in town where they can stay overnight, they walk all the way back, uphill, to their village, arriving home after dark.

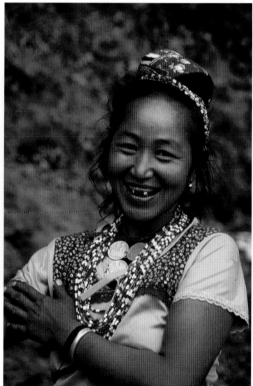

THIS PALA WOMAN wears both traditional garb and a non-traditional shirt. Thick strands of glass beads are popular among the young women. This woman's front teeth show the customary gold, and her other teeth are colored bright red with betel nut.

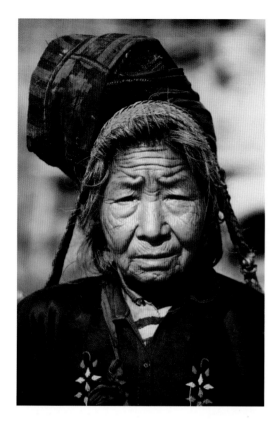

THIS OLD PALA WOMAN was walking a trail near Mueang Khua. A headband is attached to a basket of vegetables that she is carrying on her back. She is comfortably dressed in work clothes, and an embroidered shirt protects her traditional dress.

THIS MAN'S WIFE ORDERED HIM to sit and watch the drying bacon and to keep away the flies. He was not at all sad about such a mundane task. The men in this Akha Pala village near Mueang Khua seem to take a secondary role to the women, perhaps because too much opium-smoking and *lao lao*-drinking render the men quite useless for any work. Drunken partying and opium smoking disturbed the nights I spent here. The smoke, drifting into my sleeping area through woven bamboo partitions, triggered vivid and strange dreams.

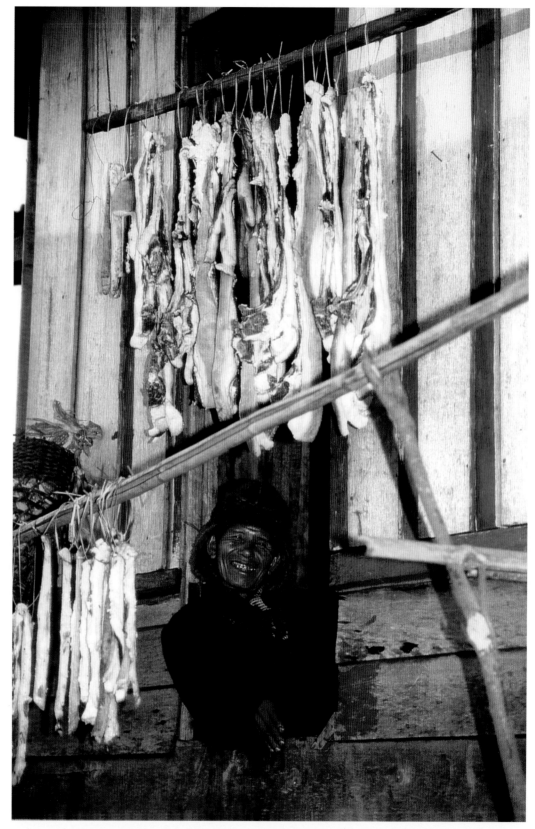

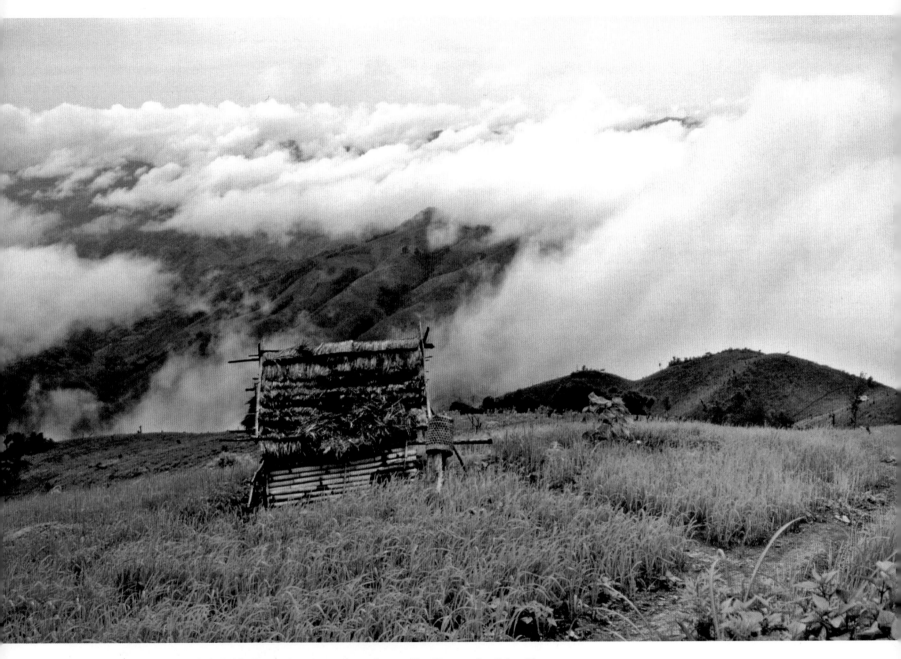

A LONE HUT STANDS in a field of mountain rice along the trail leading to the Pala village near Mueang Khua that I visited several times. It has just rained, the clouds are lifting, and the hills are fresh and green. During the planting and harvesting seasons, women or whole families stay here instead of trudging home every night.

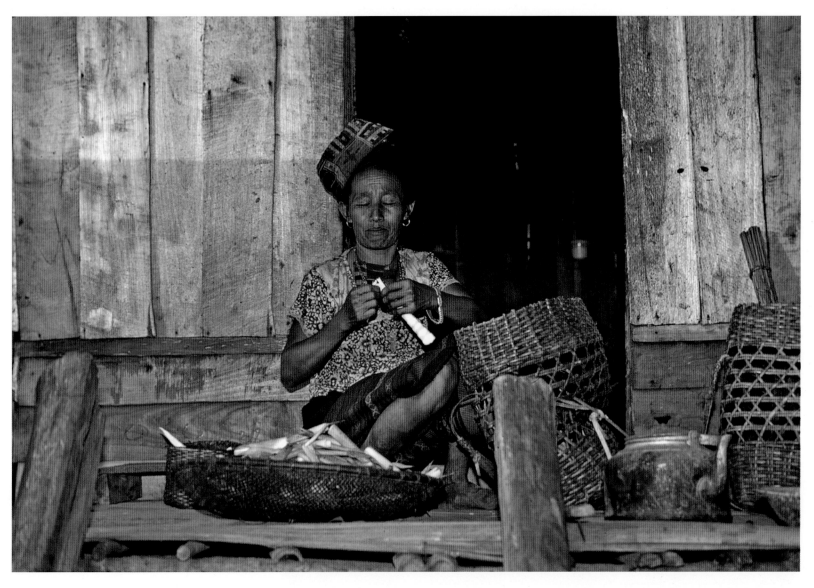

DURING A PEACEFUL LATE AFTERNOON, a Pala woman sits outside her house and cleans bamboo shoots for dinner, perhaps for a delicious bamboo soup. Most housework is done outside, when possible.

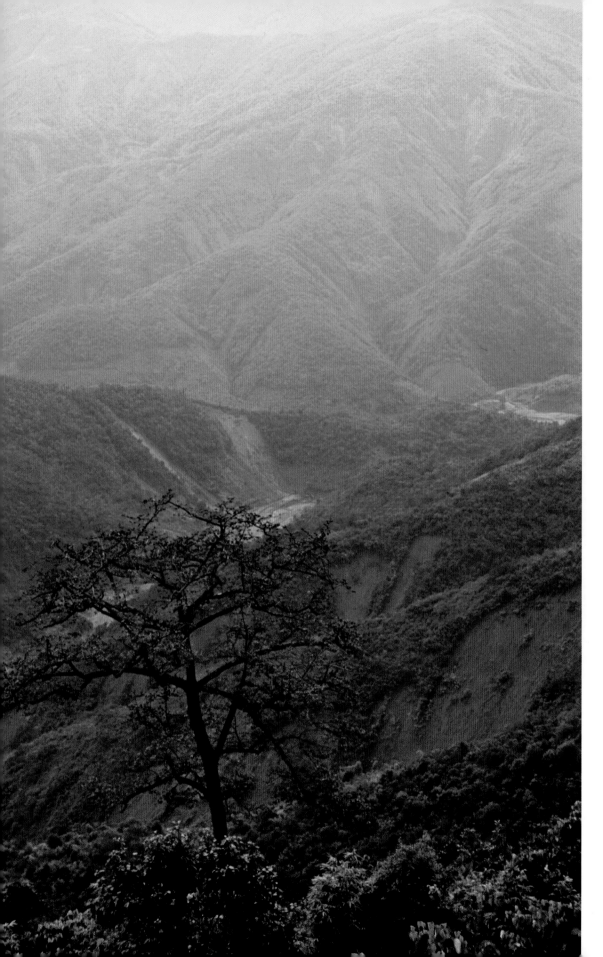

ONE YEAR, during the monsoon, it had rained more than normal, and this view from the trail to the Pala village showed landslides as far as the eye can see. Slash-and-burn practices near the hilltops promote these slides. The roots and foliage of intact forests would have prevented much of this severe soil erosion.

ONE-HOUR'S BOAT RIDE NORTH of Mueang Khua, two little boys ride a water buffalo along the shore of the Nam Ou. I snapped this picture from our longboat as it prepared to slide onto a sandbar along the shore. When the boys spotted me, a foreigner, they quickly steered the buffalo away from the river and disappeared into the brush. Our rest stop was much needed though, and the women went to one end of the beach and the men to the other.

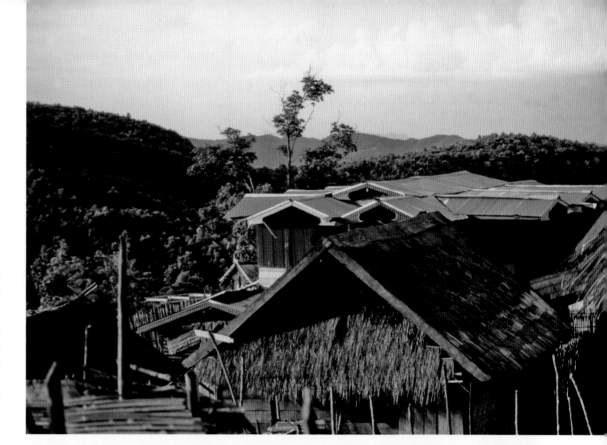

COLORFULLY PAINTED WOODEN HOUSES with carved eaves are crowding out the old bamboo and grass huts at this Pala village in the mountains near Mueang Khua. The Pala hill tribe has developed a style of housing I have not seen anywhere else in Laos. Each new house has hand-carved eaves and is painted blue and red. Every piece of corrugated iron roofing had to be hand-carried on a six-hour uphill trek on slippery trails through the mountains.

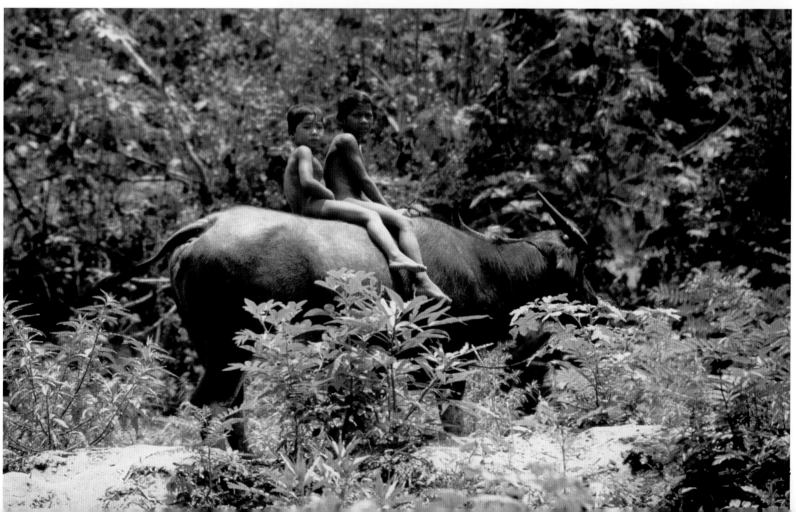

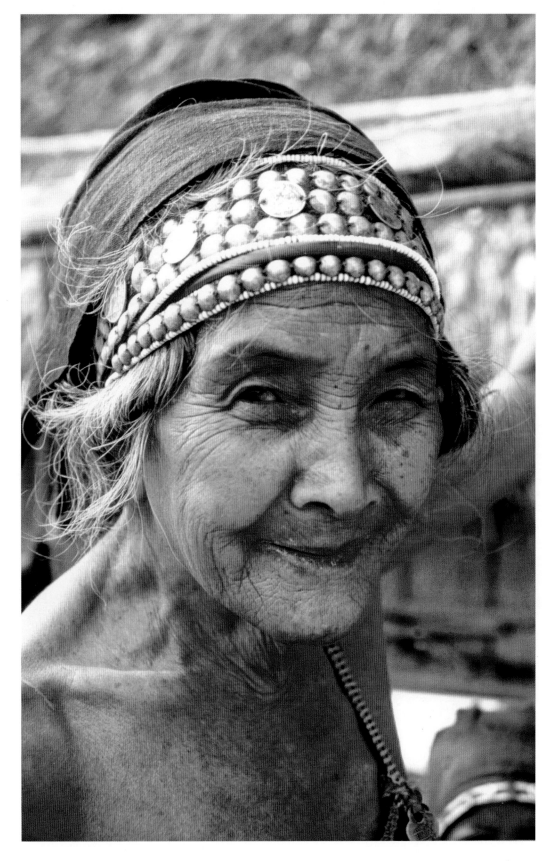

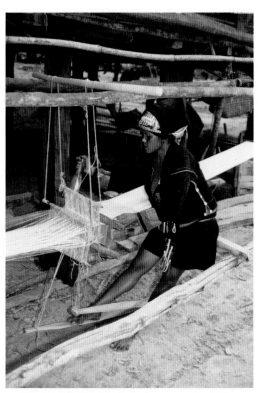

A POULY NYAI WOMAN is weaving outside her hut in Ban Lakham, a village near Mueang Sing, Luang Namtha Province. Weaving is a common occupation among Lao as well as hilltribe women. It is too dark to weave inside since most houses in the village have no windows. She wears a piece of cloth over her headgear, a common practice during outdoor work to protect against dust and dirt. All material used for clothing is woven by hand, dyed indigo blue, and then sewn into articles of clothing, which are later embroidered.

IN THE AKHA VILLAGE of Ban Lakham, an old Pouly Nyai woman is shirtless but wears a protective cloth over her modestly decorated headdress. In most hill tribes and traditional Lao villages, older women wear less elaborate headgear than their younger counterparts. Old women in remote villages often wear no tops, whereas young women would not dream of going topless. They also smile readily and are not particularly shy.

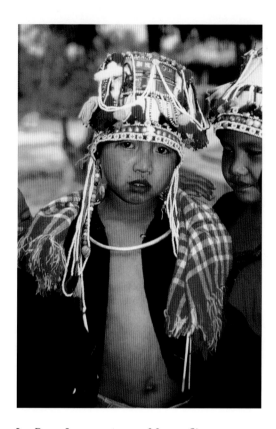

In Ban Lakham near Muang Sing, a young Akha Pouli Nyai girl cares for an infant and wears the headdress of a young woman

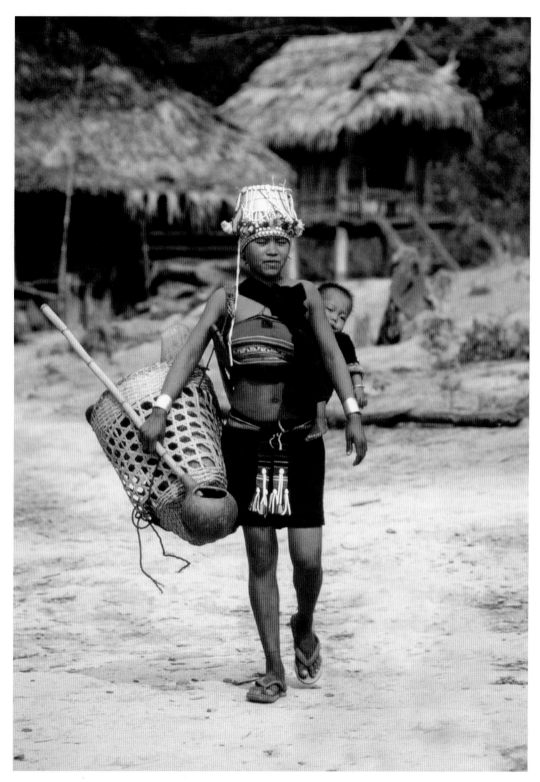

A POISED AKHA POULY NYAI MOTHER is going to fetch water in a nearby pond. She uses a basket to carry thick bamboo tubes (sometimes of hollowed wood), and a scoop made from a calabash. The baby dangling in a sling is no hindrance to this heavy activity.

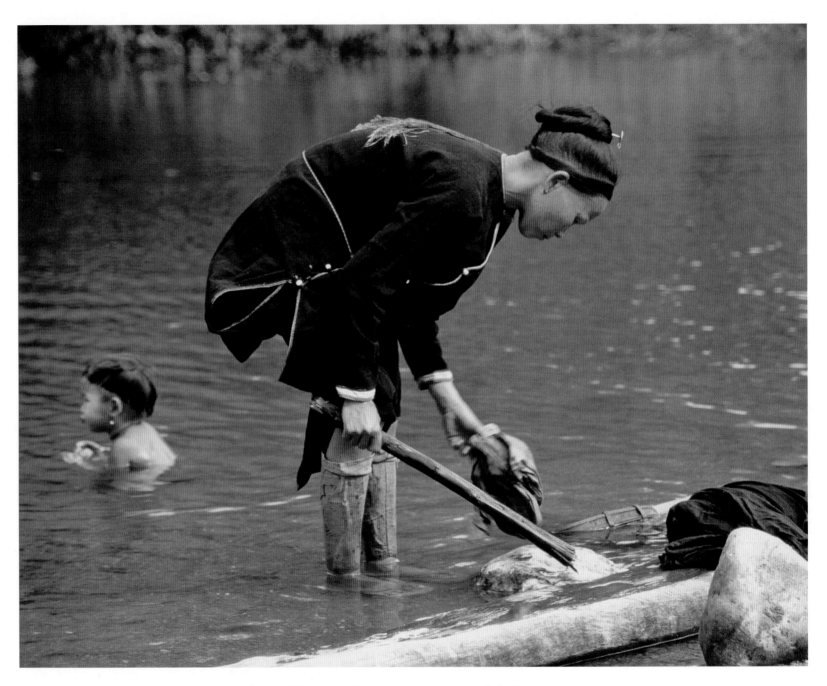

THIS SMALL POND near Mueang Sing provides an idyllic setting for a Lanten woman to wash clothes. While she beats the dirt out of the clothes with a stick, her children frolic and swim in the water beside her as if this were part of their daily routine. Her hairstyle is typical for Lanten women; the hair is first parted in a circle around her head before tying the rest up in a knot secured with a silver pin.

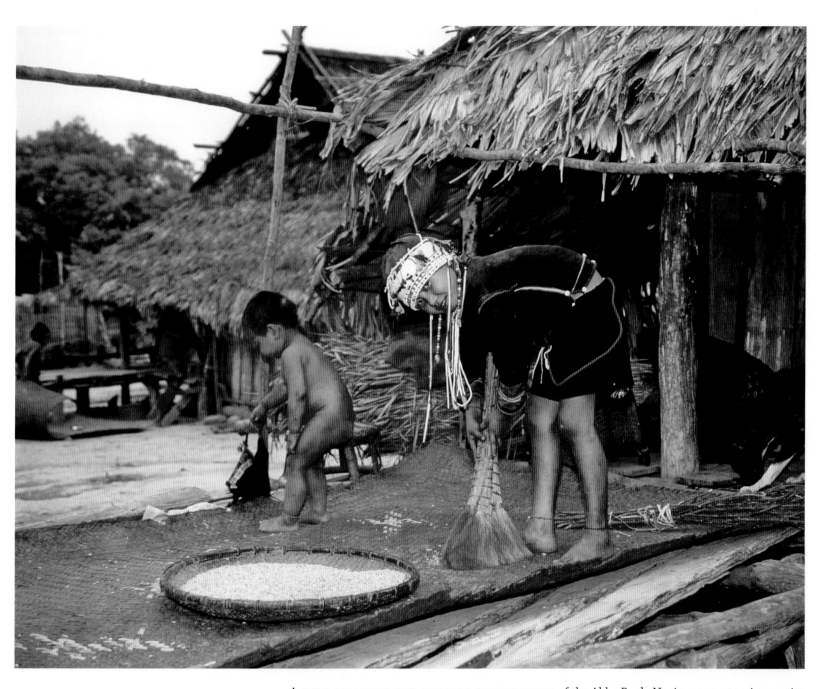

A GIRL WEARING THE TYPICAL SHORT SKIRT of the Akha Pouly Nyai prepares to winnow rice grains that have been drying in the sun on a platform in front of her hut. Without such raised platforms, someone would have to watch the rice continually, because the village fowl and pigs running around on the ground would be waiting for someone to turn their back. I have watched chicken intelligence at work, and no matter what someone might say to the contrary, not all chickens are equally stupid!

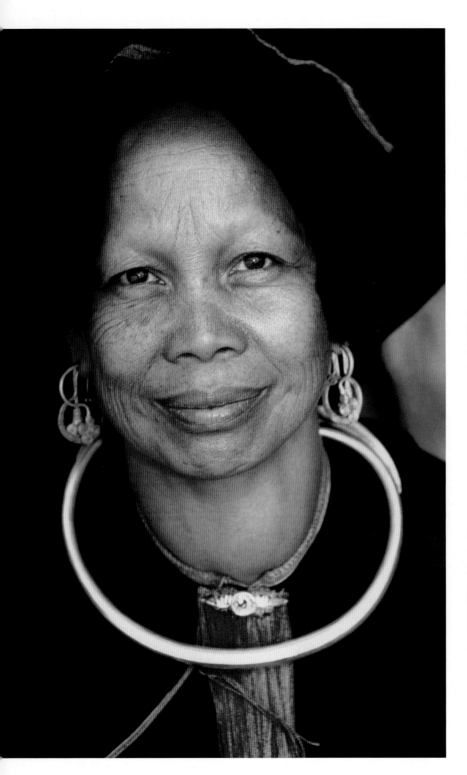

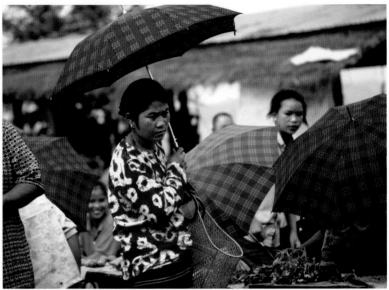

A SHOPPER AT THE LUANG NAMTHA MARKET shields herself from the sun, as the market stays open into the early afternoon. The vendors also protect their produce from the midday sun with nearly identical umbrellas. A shipment of new umbrellas, all with the same pattern, must have recently arrived in Luang Namtha.

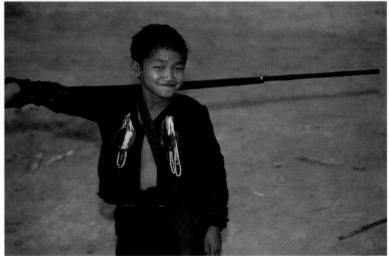

WHILE I WAITED in Luang Namtha to board a truck to Udomsai, a woman of the Lanten ethnic group provided this gracious smile in exchange for a 300-kip bowl of soup, and we both felt satisfied with our transaction.

BALANCING A RIFLE on his shoulder, this proud young Akha Pouly Nyai boy near Mueang Sing is off hunting small game, such as birds and squirrels. Many times, I have watched young boys and girls brandish rifles, slingshots, and machetes—and they are not used as playthings!

BOKAEO

A White Hmong girl in Ban Huai Sala in
Bokaeo Province is lost in thought as she holds
her little brother.

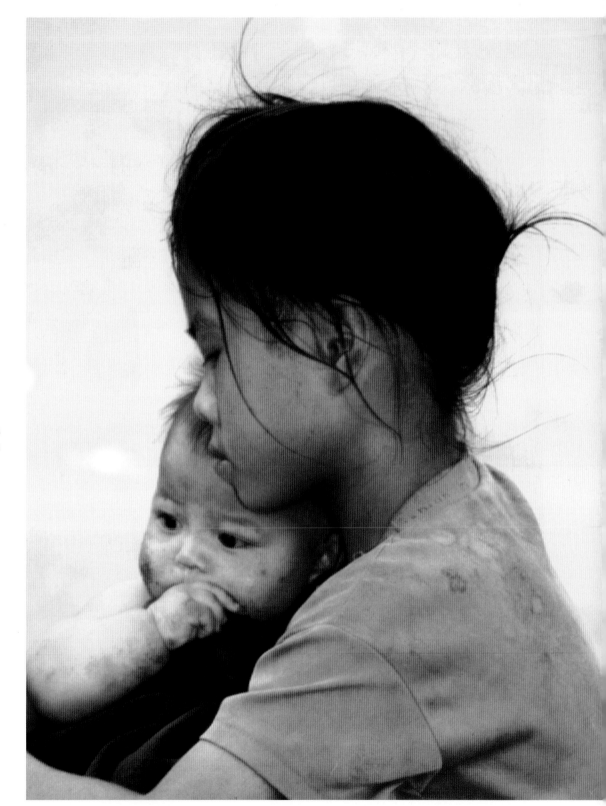

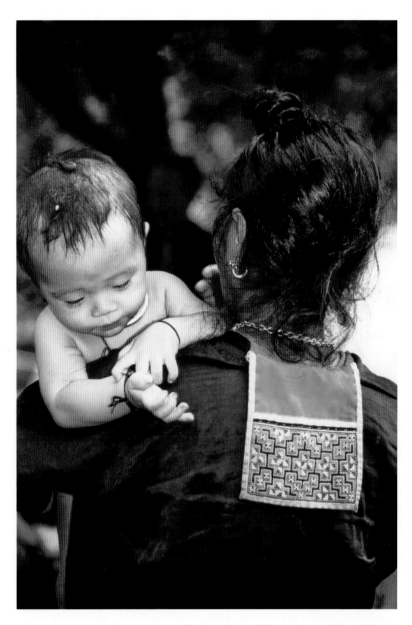

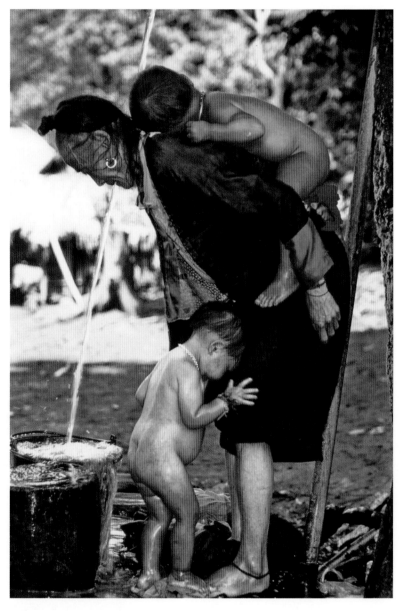

THE DECORATIVE PANEL attached to the neckline of this woman's blouse is an important part of a White Hmong woman's attire here, in Ban Huai Sala. For young girls, the quality of the panel is important in attracting a husband. Cross-stitched panels like this are worn for everyday activities, whereas intricately embroidered and appliquéd panels are worn for festive occasions.

WITH ONE GRANDCHILD HELPING her and another grandchild on her back, this grandmother stomps on the clothes she is washing. Water from a freshwater spring is transported to the village on an elevated aqueduct made from bamboo split lengthwise.

OUTSIDE THE MUEANG SAI MARKET in Udomsai Province, a White Hmong woman turns around to show me the back of her headgear. It displays intricate needlework called *paj ntaub* "flower cloth." The cross stitches are so tiny that it resembles woven tapestry.

A YOUNG WHITE HMONG WOMAN wears an embroidered headdress with yarn tassels. I photographed her in the well-stocked vegetable market in Mueang Sai. Hilltribe people at this market are commonly shy, but this girl proudly faced the camera. Mueang Sai is not a pretty town, but the market is made colorful by visits of various hill tribes.

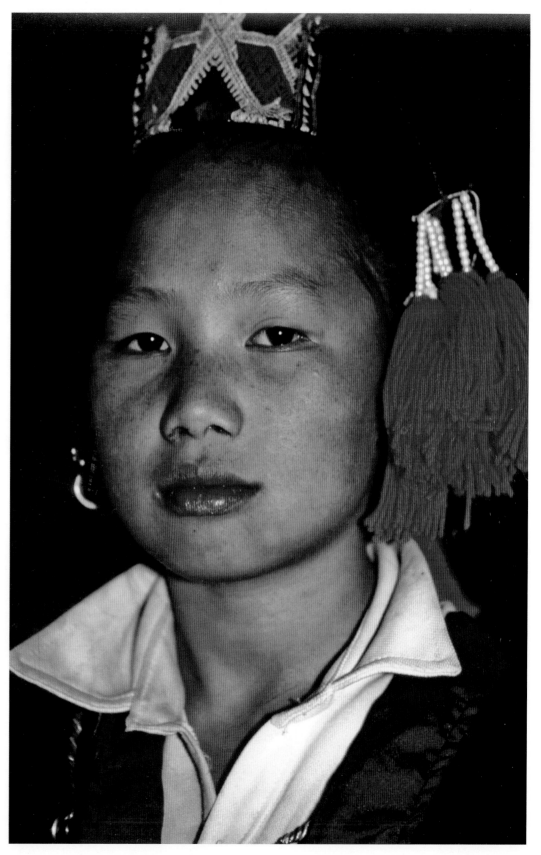

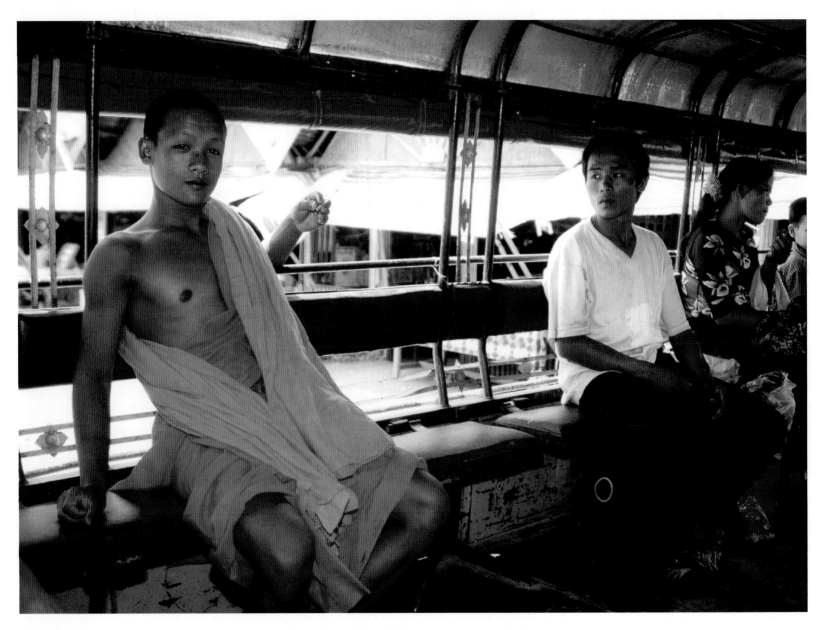

A MONK SMOKES one cigarette after another while waiting in the back of a canopied pickup truck to depart on an arduous journey over potholed and muddy roads. Smoking may fall into a gray area of Buddhist ethics, but most Lao monks adhere to a relaxed philosophy. I have also watched as they play soccer with children in the temple courtyards, sing to themselves, listen to soft rock on the radio, play checkers, and conduct other everyday activities for their own amusement. Lao monks are friendly and are always prepared to practice English with a foreign visitor.

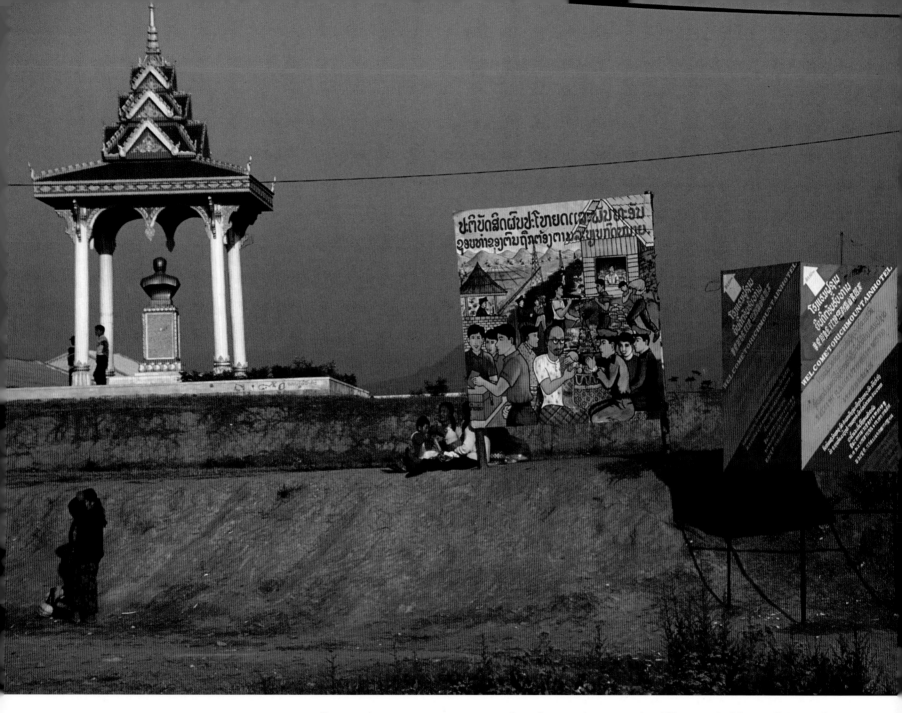

THIS WAS A TYPICAL SCENE on a hot afternoon in 1995 at the old bus stop in Mueang Sai, near the colorful morning market. A family waiting for a ride has a relaxed lunch, while a woman standing at the curb patiently waits for a truck. Lunch in Laos is never a hurried business—the Lao people are extremely relaxed and patient. The monument at the left is dedicated to Kaysone Phomvihan, who founded the Lao People's Liberation Army, and died in 1992. Identical monuments sprang up nearly simultaneously in many small towns throughout Laos. The hand-painted poster in the middle states approximately, "Fulfill your destiny and meet your responsibilities according to the law." By 2003, the whole area surrounding the monument was surrounded by a decorative metal fence, and the poster was gone.

Colorful shop houses line Thanon Sisavangvong in the old royal capital of Luang Phrabang. Some of these shop houses contain small businesses catering to the locals but are usually closed during the hot afternoon, as shown here. This photo was taken in 1994, before every dwelling was turned into a souvenir shop, restaurant, or guesthouse for tourists. Now, after an influx of tourist money and Luang Phrabang's designation as a UNESCO World Heritage Site, many buildings have been restored, and the shop owners display textiles, silver jewelry, and other handicrafts all day for the benefit of foreign visitors.

Strolling along the streets and lanes in Luang Phrabang in 1994, visitors could see colorful shutters against walls with peeling paint, reminiscent of a Mediterranean locale. Unexpectedly picturesque scenes like these are not as common anymore, because every old Lao or French colonial building downtown is being renovated and repainted. Potted plants are still clustered outside homes, shops, and *wats*, though, not only in Luang Phrabang, but also in most other Lao towns. In the evenings, the sidewalks turn wet when people water their plants.

BOYS CLUSTER AROUND a game only boys know. The backdrop is a shop house along Thanon Ounkham by the Mekong River. This relatively recent building was probably built in the 1970s and is made quaint not by its architecture, but by its peeling paint. Some of the newer generation of buildings in Luang Phrabang are as eye-catching as the old Lao-French colonial buildings.

THIS IS THE SAME BUILDING in 2003, with the paint almost entirely peeled off. Although the street next to the building is being repaved, this building has no cultural significance and is therefore not considered worthy of renovation.

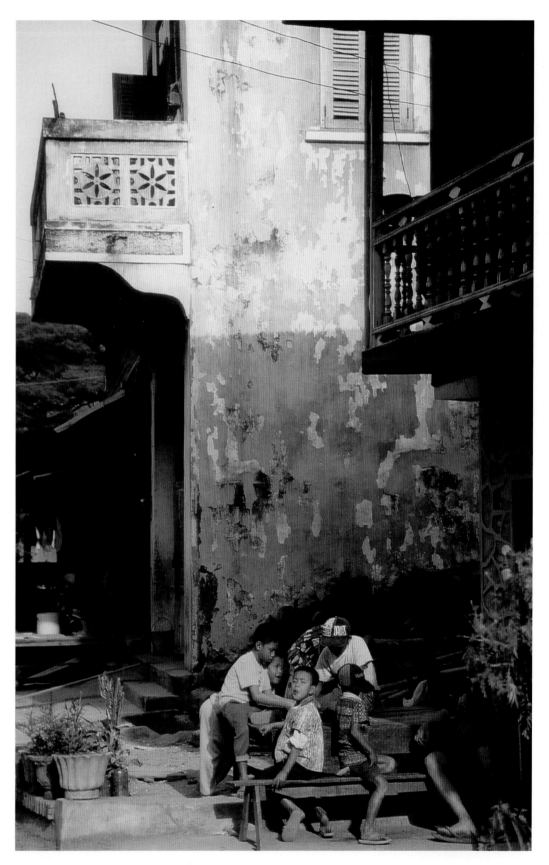

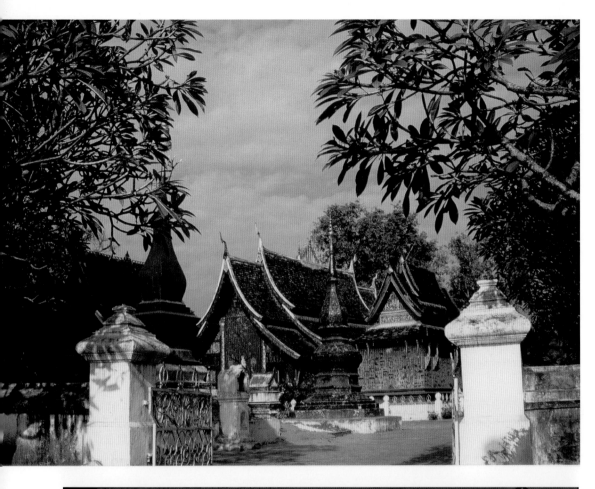

FRAMED BY A WHITE WALL and *champa* (frangipani) trees, Wat Xieng Thong is one of Luang Phrabang's oldest and most photographed *wats*. It was built by King Say Setthathirat in 1560 and represents a typical Luang Phrabang architectural wat style. This *wat* has survived wars and invasions nearly intact, which is unusual in Laos. A reclining Buddha figure as old as the *wat* itself resides in what was named La Chapelle Rouge by the French. The temple grounds also contain the royal funerary carriage house.

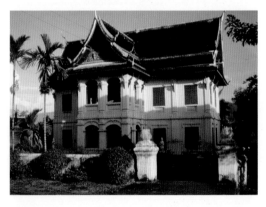

BUILT IN 1773, this architecturally elegant "meeting house" (*kadi*) at the seldom-mentioned Wat Khi Li (also called Wat Suvanna Khili) on Thanon Sakkalin in Luang Phrabang needs no excess gilt and ornamentation to be beautiful.

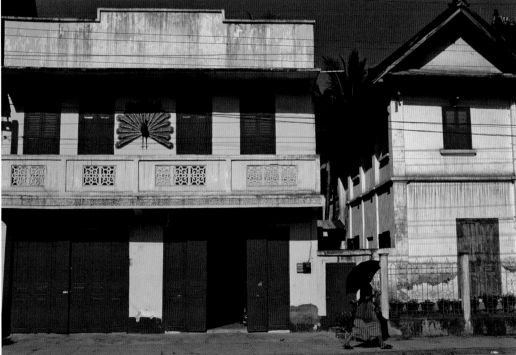

EVEN DRAB, MODERN CONCRETE buildings in the outskirts of Luang Phrabang can acquire the quaint charm typical of the older colonial buildings. In this case, all that was needed was some bright paint and a peacock ornament.

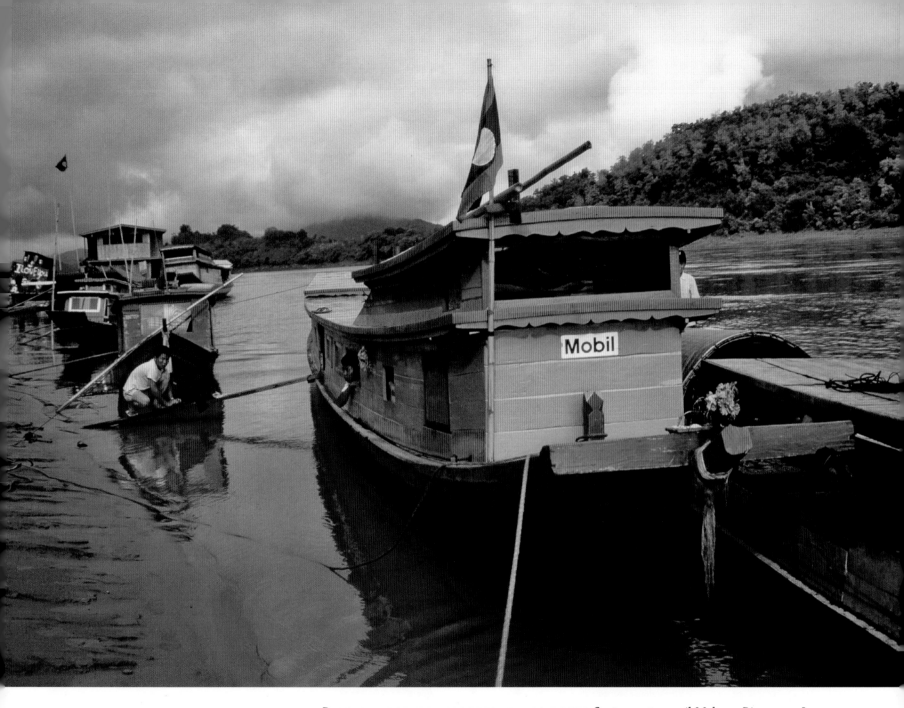

Brightly painted wooden cargo boats float on a tranquil Mekong River near Luang Phrabang beneath a rain-heavy, leaden sky on a hot and humid afternoon. It is too hot to do anything more strenuous than washing clothes in the river, like the man at the left. The "I love you" sign barely visible on the most distant boat at the left clashes with the "Mobil" sign on the boat at the right.

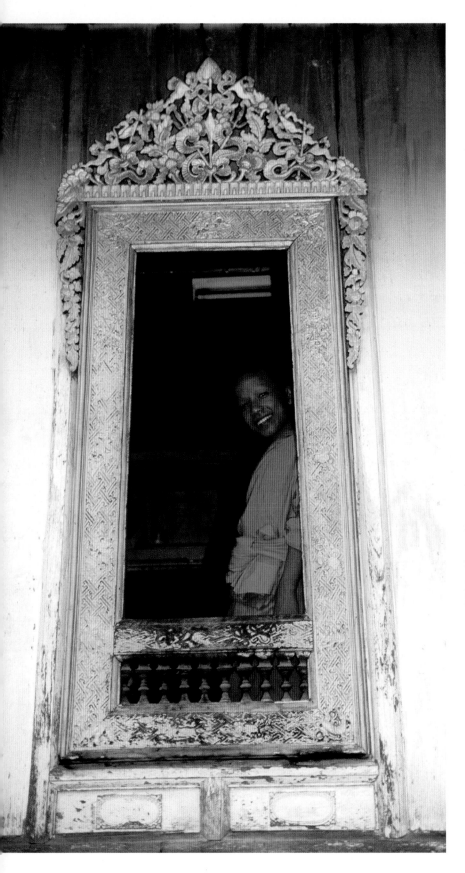

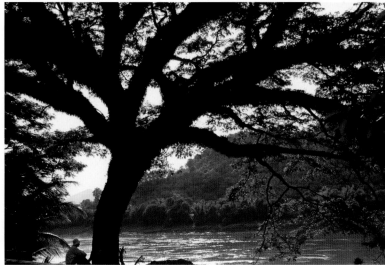

A LARGE SHADE TREE next to the Mekong River in Luang Phrabang, is covered with epiphytes and moss and provides a comfortable spot for relaxing. Luang Phrabang is one of the most relaxing towns, in a relaxed country, and just sitting around chatting is the norm, not a luxury.

FRAMED BY POTTED PLANTS and greenery, this newly refurbished house along Thanon Rathsavong in Luang Phrabang, was painted in colorful and contrasting colors.

A NOVICE SMILES from an ornately carved and gilded window at Wat Phra Maha That. Beneath the window are steps lined with huge serpents called *naga* leading up from the street below (Thanon Chao Fa Ngum). The *wat* is named after a stupa built here in 1548.

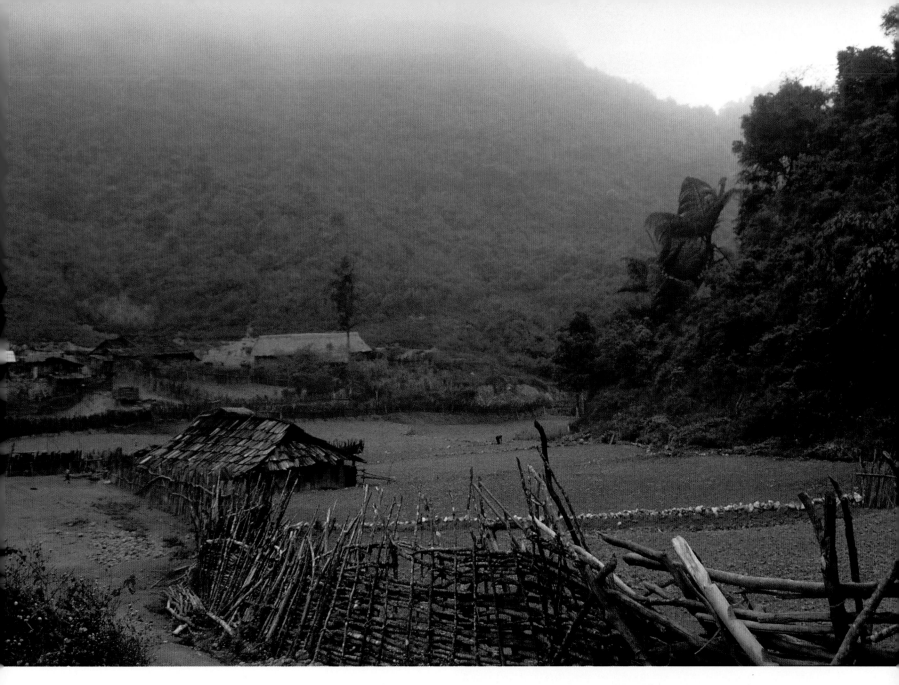

SIANG KHUANG PROVINCE

BAN PHAVEN, A MISTY HMONG VILLAGE in eastern Siang Khuang Province, is the starting point for a long downhill trek to a Lao Thoeng village. A 7 km distance, a 1500 m elevation, and different languages and ethnicities separate the two villages. Our Hmong porters happily stayed with Lao Thoeng friends in Ban Namuang and even spoke their language. We spent a night there after sampling sediments in the rivers Nam Khiang and Nam Mo on the Lao-Vietnamese border.

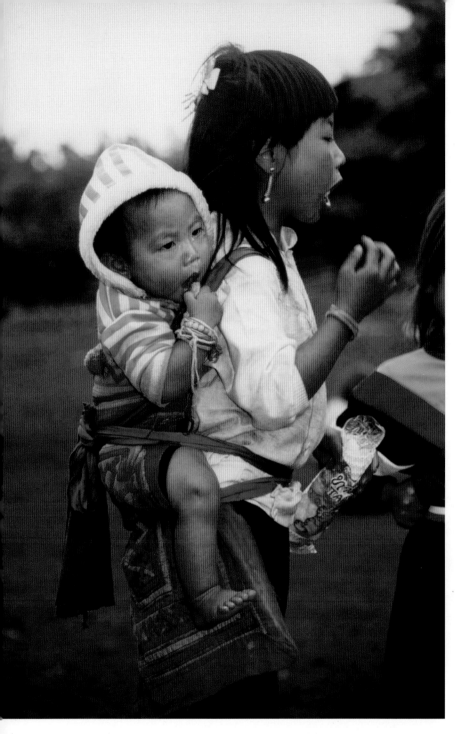

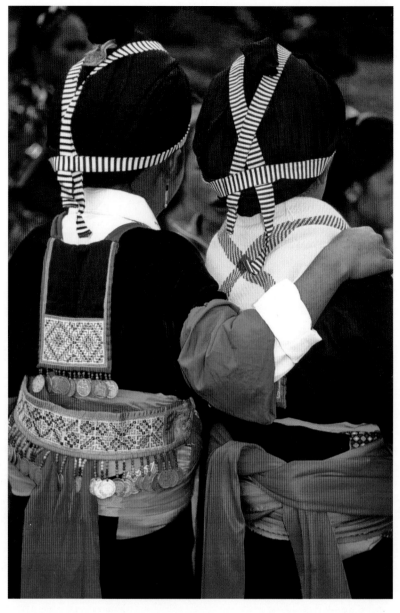

Friends show off their finery during the Hmong New Year's celebration in the little village of Ban Thachok—despite a lack of prospective husbands. Their costumes, with blue sleeves, green waistbands, and hot pink sashes, are typical of the Blue Hmong. The embroidered belt with dangling silver coins is worn on special occasions.

Hmong children feast in unison on snacks during the Hmong New Year's celebration in Ban Thachok, Siang Khuang Province. Hmong women are well known for their intricate needlework, shown here as finely cross-stitched and appliquéd geometrical patterns on the baby carrier.

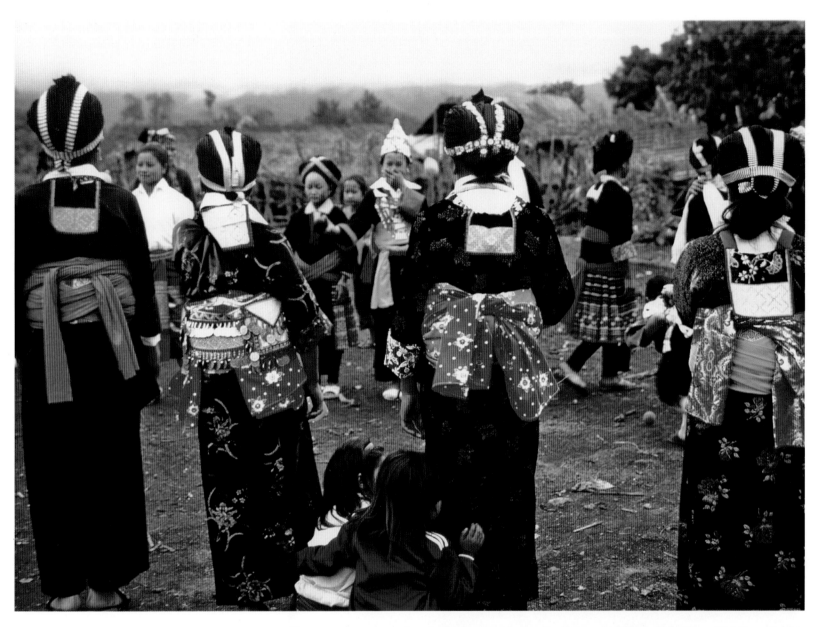

HMONG MAIDENS play a ball toss game during the Hmong traditional New Year, Kin Jieng. In this game, a ball made of cloth (or an orange as in this photo) is thrown back and forth between girls and boys. If one of them drops the ball, that person must sing a traditional song or give a small present, like a silver piece, to the person who threw the ball. Parents watch and might select their future sons- and daughters-in-law this way. A pitiful lack of male participants during this particular game in 1995 did not seem to render the girls the slightest bit unhappy!

IN REMOTE VILLAGES, spirit altars like this stand at auspicious locations, such as the entrance to a village, or as here, at a stream crossing near a small village in Siang Khuang close to the Vietnamese border. This spirit altar has crude clay figures of elephants and other animals tucked into small compartments, perhaps to appease the spirits of elephants lost from the "land of a million elephants," a former name for Laos.

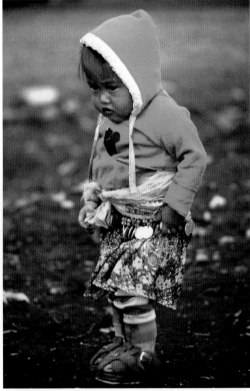

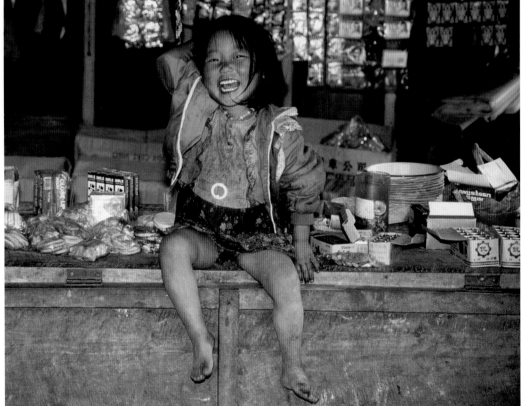

WITH NEW, SQUEAKY SANDALS on her feet, and dressed for a chilly December morning, this little Hmong toddler crosses the road by herself, while her mother stands offering encouragement. Fortunately, the traffic on this road, as on most rural roads in Laos, is nearly nonexistent.

"NO, YOU CANNOT BUY ME!" exclaims this little girl in a shop in Ban Sandon. Her mother put her on the counter while she went to get something in the back for us. Meanwhile, we joked with the girl and asked how much she cost.

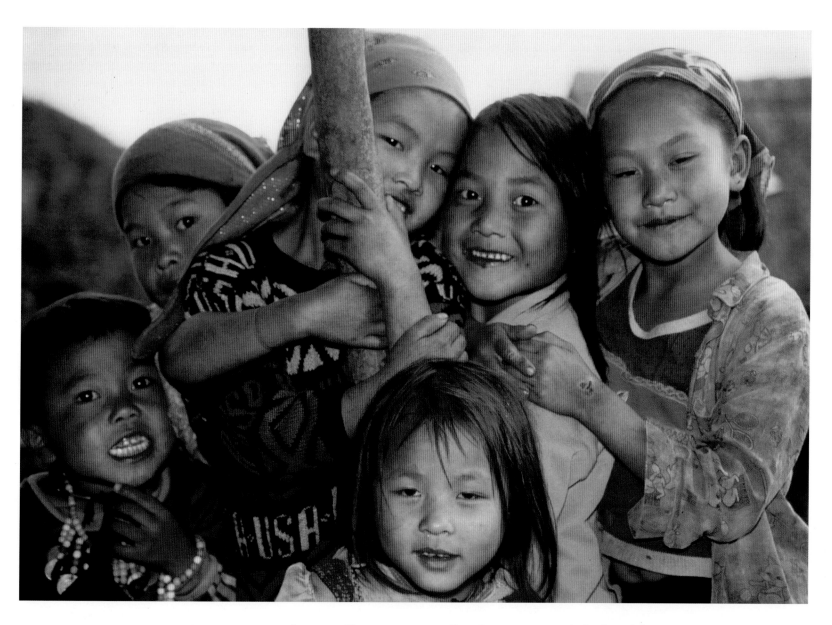

SMILING HMONG GIRLS IN BAN SANDON approach slowly and then encircle me after first having assured themselves that I am not dangerous. I was enjoying the view while waiting for a Russian jeep that would transport us back to Route No. 7 after we hiked up from the valley of Nam Huai near the Vietnamese border in eastern Siang Khuang Province.

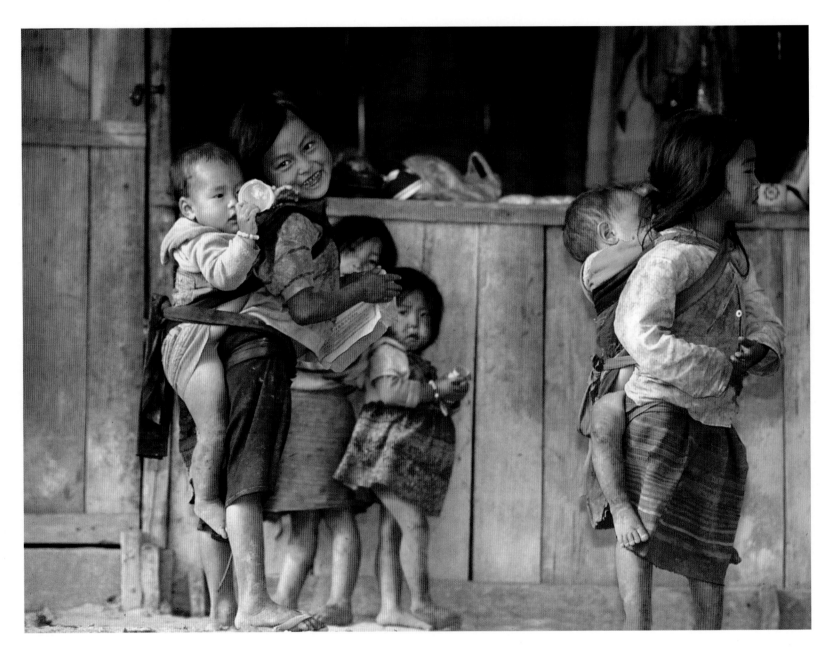

HMONG CHILDREN IN BAN SANDON are, like many other Lao children, often in charge of their younger siblings while their mothers are busy. Even while carrying what to them must be heavy burdens, young five- to six-year-old girls still manage to play. As I watched these little girls caring for their siblings, boys unburdened by this task played games with hand-carved, wooden tops.

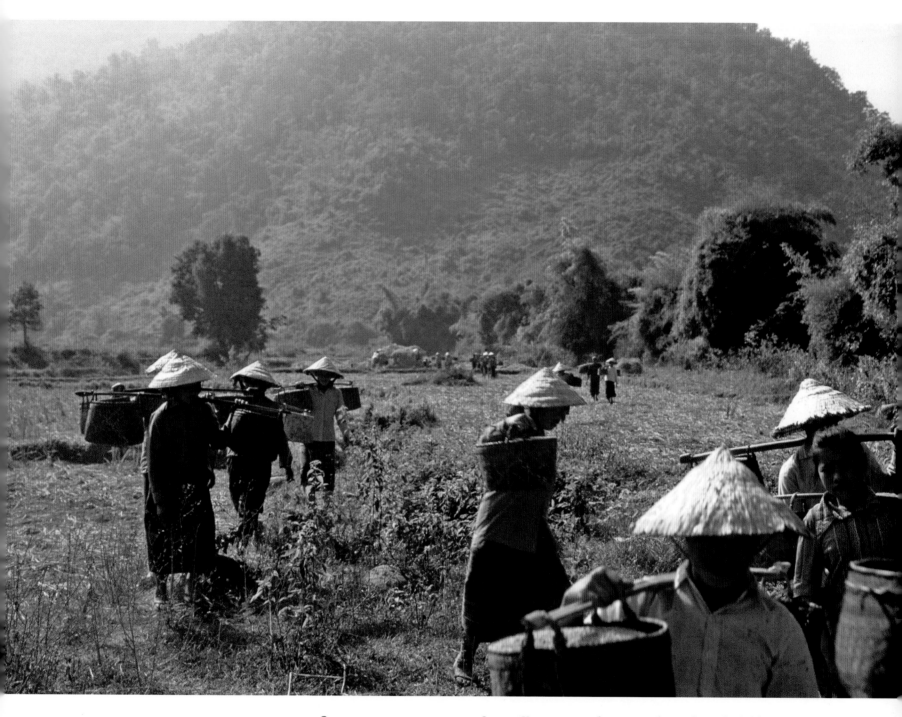

On a late afternoon in Siang Khuang, workers return home from the fields with baskets full of grain slung over their shoulders. Their wide straw hats effectively protect them from the sun.

VIENTIANE PROVINCE

THE MORNING SUN ILLUMINATES this golden *wat* in Ban Phatang, about 20 km north of Vang Viang. Behind the *wat* is one of the many steep hills in the Vang Viang area formed by the dissolution of limestone. Near the *wat*, the road forks off to a valley enclosed by limestone crags planted with landmines and accessible only by walking on wet, slimy logs across a stream flowing through a hidden natural cave. I could have stood next to this cave opening and not even seen it.

THIS RED DRAGONFLY near the shore of Nam Ngum, about 90 km northeast of Vientiane, is one of countless dragonflies of many colors inhabiting swamps, lakes, and stream banks in Laos. With few predators, such as birds, which are hunted for food by villagers, Laos is a paradise for dragonflies, butterflies, and entomologists.

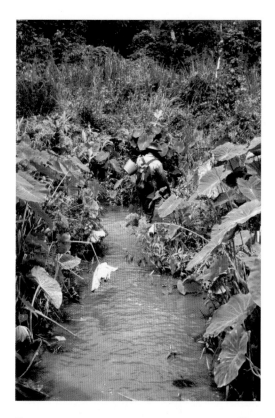

SOMETIMES, AS HERE IN A VALLEY near Kasi, northwest of Vang Viang in Vientiane Province, the only possible "trail" to follow during geologic fieldwork is a muddy creek. This "trail" is in a valley that I informally named the "valley of the leeches" because of the numerous little parasites lying in wait on every bush and leaf. The soft mud in the creek was not too bad for walking, though.

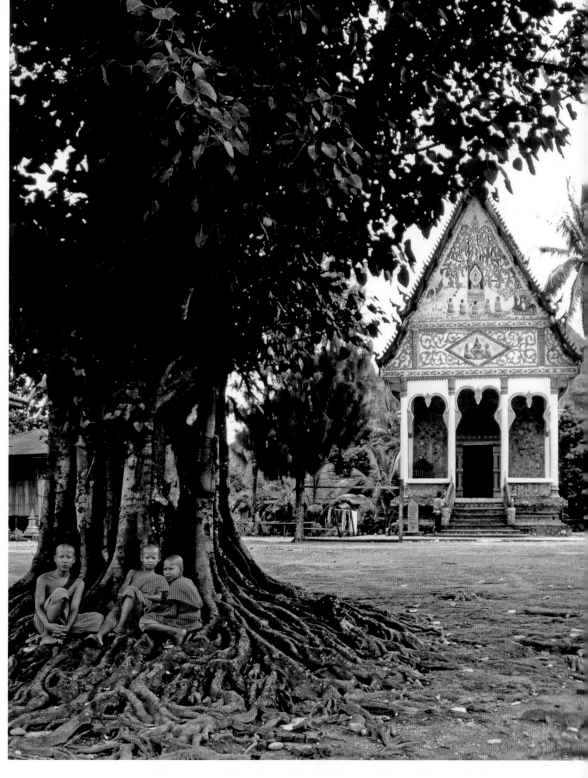

ON MY FIRST VISIT TO VANG VIANG in 1993, novices, still shy of foreigners, sit in front of a sacred tree at tiny Wat Kang. During a later visit in 2001, no novices were in sight, and the roots of this tree were covered with sand being used for building. All the greenery next to the *wat* had been chopped down since this photo was taken.

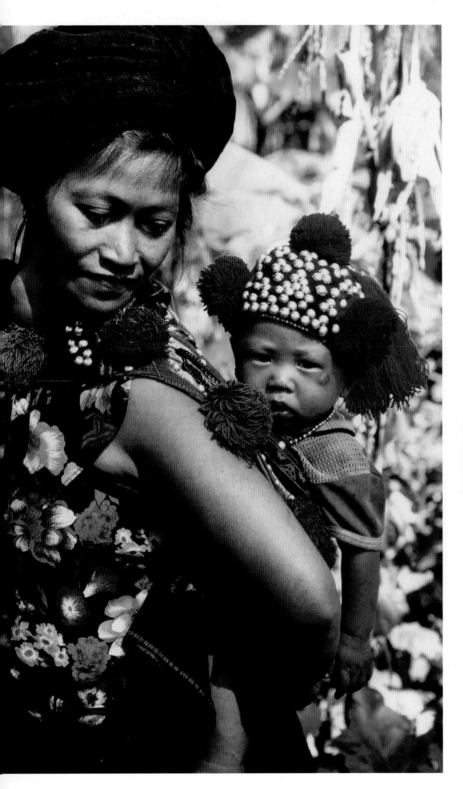

NEAR KASI, VIENTIANE PROVINCE, this Mien mother and child could walk where we could not because she knew the karst terrain, which was planted not only with corn, but also with land mines. Some of the Hmong rebels causing trouble for the government supposedly hid in caves in this area and mined the access routes. The goiter (an enlargement of the thyroid gland) on this mother's neck testifies to the lack of iodized salt in the area. Goiters are common in Laos, and I got many perplexed looks when I gave gifts of iodized salt.

ON A STREAM BANK NEAR VANG VIANG, this butterfly landed in front of my camera, right after the butterflies I intended to photograph had flown off. Butterflies commonly congregate along dried-up stream banks. When the water recedes, it leaves a salty residue to which butterflies are attracted.

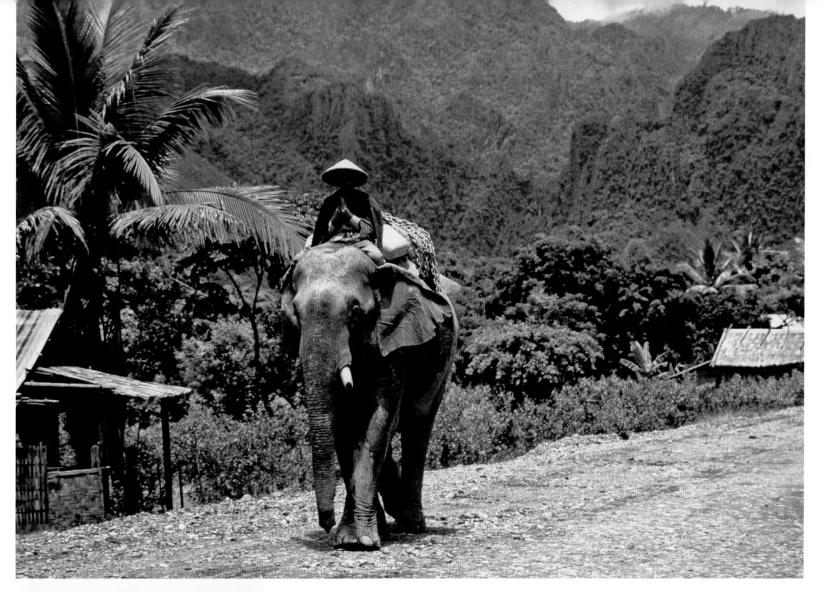

THE MAHOUT OF THIS WORKING ELEPHANT greets my fellow geologists and me on the road just south of Vang Viang, a small town approximately 150 km north of Vientiane. At the time of this visit, in 1994, Vang Viang was a tranquil little town, largely unknown to backpackers and nearly devoid of guesthouses. We worked nearby in the bush, and we stayed with an official in his home because of a lack of other accommodations. Now, Vang Viang is a mecca for backpackers and has scores of guesthouses competing for guests. Seemingly, more tourists than locals ply the streets—perhaps helping the economy but detrimental to the tranquility that once prevailed.

A NATURAL CONGLOMERATION of colorful pebbles brightens a small stream west of Vang Viang. Walking in the clear, warm water of the small streams provides rewarding photographic opportunities, although most visitors to this area search out dark caves in the karst terrain.

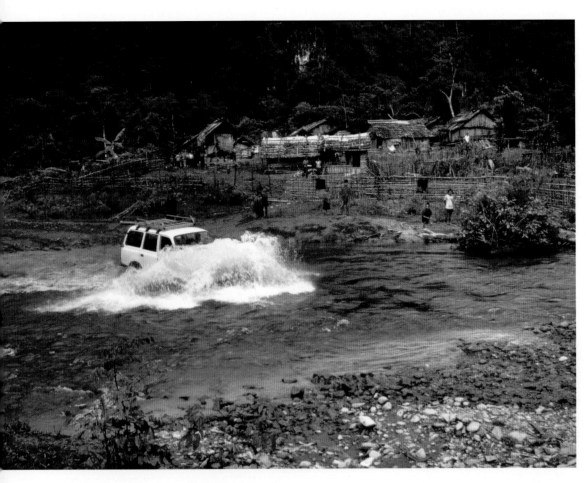

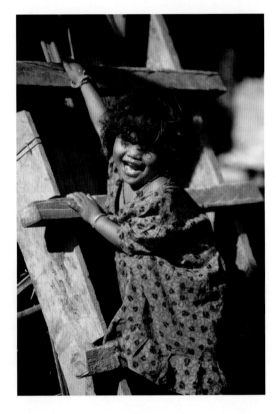

OUR DRIVER, LY, FORDS THE STREAM Nam Sanen, east of Ban Phatang, about 20 km north of Vang Viang. Most rivers we crossed during fieldwork had no bridges but were generally wide and shallow. Crossing this river, however, required planning because it was narrow and deep. While all the inhabitants of a small Hmong village watched in awe, Ly revved the engine and literally "flew" across the stream, water rolling over the hood—but he made it.

THIS LITTLE LAO THOENG GIRL is doing everything in her power to entertain us while we wait for permits to sample stream sediments in an area about 20 km north of Vang Viang. Permits and armed guards were needed to enter this area, which was inhabited by Hmong guerillas and planted with land mines. The little girl ran up and down the ladder to her hut while squealing with laughter. She has curly hair, unusual in Laos, although I subsequently observed other Lao Thoeng individuals with curly hair, perhaps a legacy of their Austro-Asiatic origin.

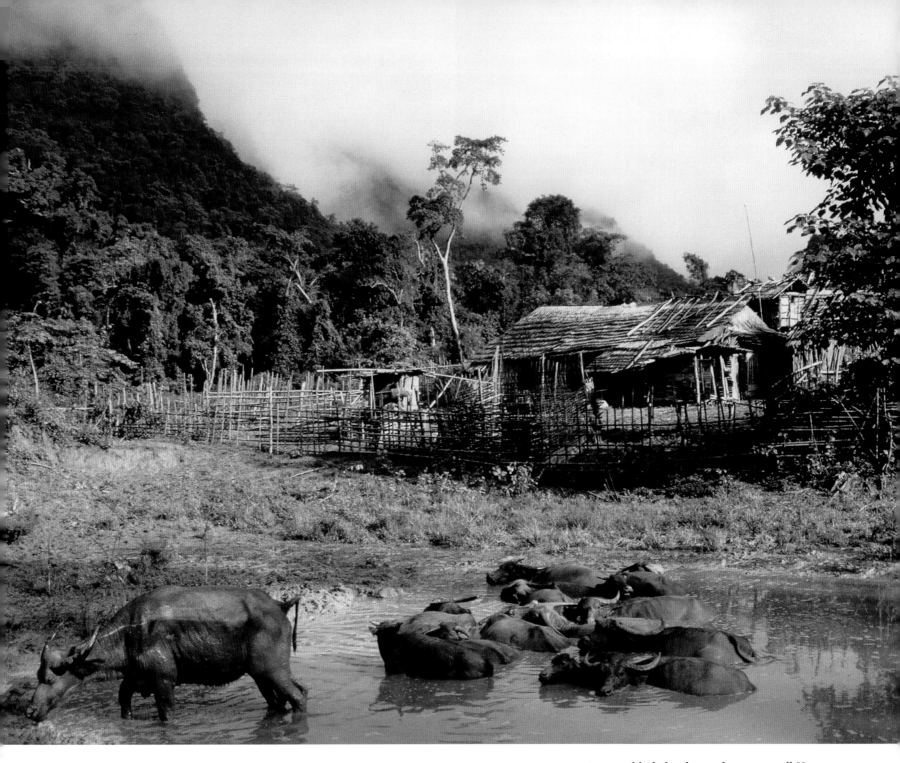

WATER BUFFALOES CONTENTEDLY WALLOW in a mud hole by the road near a small Hmong village east of Ban Phatang. Big, lumbering creatures, water buffaloes are now as common in Laos as elephants once were. The buffaloes block roads with impunity and may refuse to move out of the way of a truck. Commonly, at night, they sleep on village roads, and their dung makes roads slippery for motor vehicles. Many of the Lao water buffaloes are pink, unlike buffaloes I have seen anywhere else in Asia.

On the eastern outskirts of Vientiane, a woman pulls up rice seedlings to be replanted elsewhere. The work is backbreaking, but soft mud makes it a pleasure for the feet. The rice paddies in this area are now disappearing as suburbia encroaches; the fields turn into dust as they are drained, and then they are covered with dirt to make room for new roads and buildings.

A contorted, stunted tree grows from a crack on Phu Khao Khuai, a mountainous plateau northeast of Vientiane. Many of the trees in this unique area of water-eroded sandstone barely survive in crevices in the exposed rock. Amazingly, the trunks and branches are commonly covered with blooming orchids. This tree, however, displays only pseudo-bulbs, which retain water during dry spells. After I took this picture in 1995, people from nearby villages discovered that expatriates and Lao residents of Vientiane would pay good prices for orchids. Some of the vegetation that I had photographed was gone the next time I visited. Not only had the orchids been plucked off the trees, but the trees had been cut down as well, in some cases just to reach the orchids. Most of the trees had been hauled off and used for firewood.

EROSIONAL POTHOLES ARE NUMEROUS in the sandstone of Phu Khao Khuai, and they occur in many interesting shapes and forms. Some potholes are filled with murky water, others just with pebbles. Rivulets of clear water running from one hole to another connect some of the deeper holes. Such potholes serve as perfect swimming holes when the surrounding sandstone heats up to become unbearable.

A WINGED DIPTEROCARP FRUIT lies among rosettes of new grass on Phu Khao Khuai, about 90 km northeast of Vientiane. Relying on the forest to provide photogenic subjects in this area can be disappointing because the forest is being chopped down as in so many other places in Laos. Looking down on the ground, however, reveals interesting micro-environments, like this.

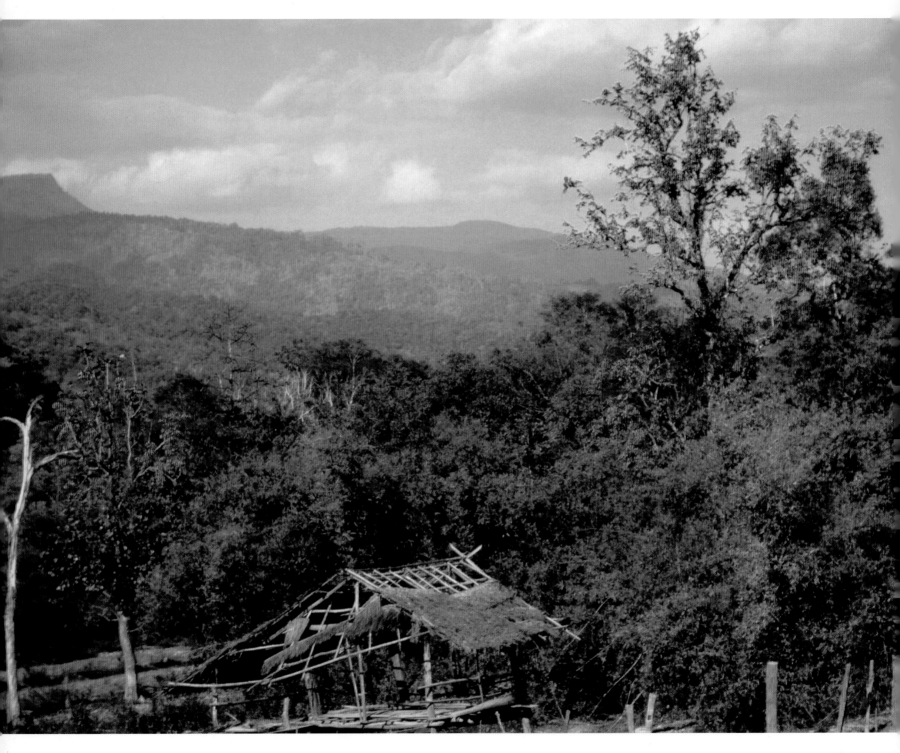

THE RED BLOSSOMS on this tree, a few kilometers north of Paksan, along Route No. 13 South, lasted for several weeks. I passed this tree when I drove to Vientiane on weekends while working on a road project in Paksan. The hills in the background are part of the Phu Khao Khuai plateau.

On a hot, dusty afternoon during the dry season, in the countryside west of Vientiane, one of my Lao colleagues walks ahead to ensure that a log bridge will hold when we cross this stream. These bridges are sturdier than they look and are practical as well. During the rainy season, flooding commonly dislodges the logs. During the dry season, the logs can be reused to rebuild the bridge, unless, of course, they have been washed away.

West of Vientiane, a bus sits in a ditch waiting to be pulled out of the mud. During the monsoon, public transport is haphazard at best, and many were the occasions when I passed a bus that was stuck or had to wait for a bus to be pulled out of a ditch. The passengers would patiently sit inside the stifling bus waiting for help for hours. Usually a truck or a bus with a winch would finally show up.

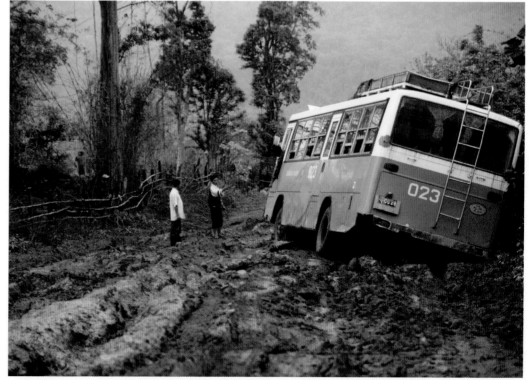

VIENTIANE CITY
AND SURROUNDINGS

DURING THE ROCKET FESTIVAL in Vientiane, men turn away from a bamboo rocket as it blasts off from a high scaffold. This is a wild and festive pre-Buddhist rain ceremony, with much music, dancing, drinking, and masquerading in clothes of the opposite sex. Lao women, who are normally shy and modest, may carry huge carved wooden phalli in suggestive postures, and men dress to look like pregnant women. Fertility in general is promoted in many bizarre forms.

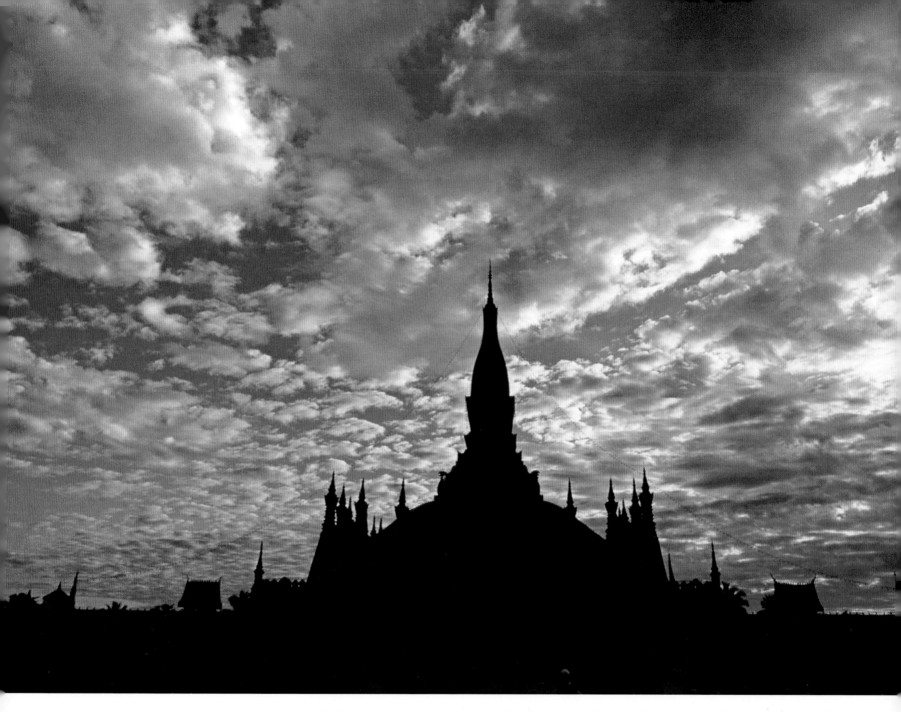

IN NOVEMBER 1993, before lights illuminated the That Luang stupa in Vientiane essentially around the clock, I arrived just at dawn for the yearly That Luang Festival and found the nearly dark stupa in lonely splendor silhouetted against the early morning clouds. It was anything but lonely on the grounds around the stupa, however, as thousands of people including monks crowded together, waiting for the various events of the morning to commence.

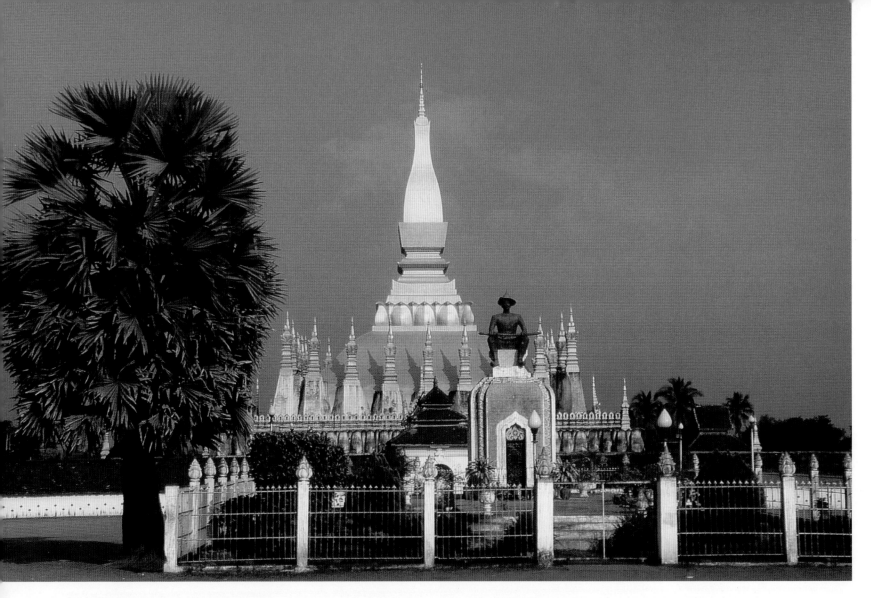

ON A SUNNY DAY, the That Luang stupa, recently refurbished and re-covered in gold leaf, shines in golden grandeur. The simplicity of design is in sharp contrast to the overly ornamented *wats* nearby. Legend claims that the original That Luang stupa had been erected more than two thousand years ago and contained a breastbone of the Buddha. Excavations, however, have found only the remains of a Khmer temple dating to between the eleventh and thirteenth centuries. The stupa attained its present form during the reign of King Setthathirat, who, in 1566, had it covered in gold leaf. The That Luang was badly damaged by several foreign invasions and was reconstructed in the early twentieth century. The fence-enclosed statue in front of That Luang represents King Setthathirat.

EVERY NOVEMBER, during the weeklong That Luang Festival in Vientiane, hundreds of monks and novices from all over the country congregate around That Luang stupa, a national shrine and symbol. I played peek-a-boo behind my camera with these young and initially solemn novices. Then, all of a sudden, they broke into these smiles. They quickly regained their composure, though, after stern looks from their elders. They had a long wait for their share of alms because they were only two little novices in a sea of hundreds.

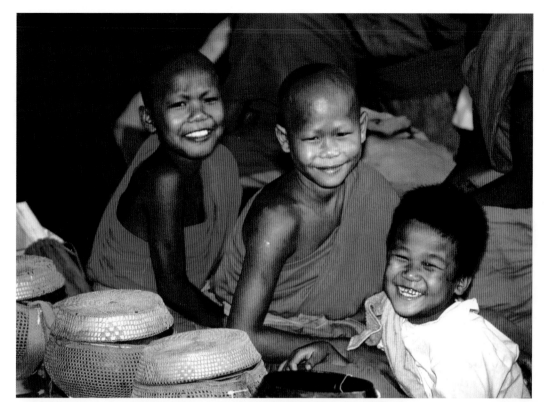

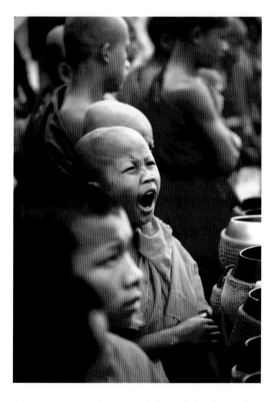

AT DAWN, on the second day of the festival, a yawn from a young novice is fully understandable.

BAREFOOT WOMEN in their finest *sin*, handwoven in silk and gold thread, stand in line to offer votive food to the monks during the That Luang Festival in November 1993. The That Luang Festival provides a great opportunity to admire the most beautiful, traditional *sin* made by Lao women.

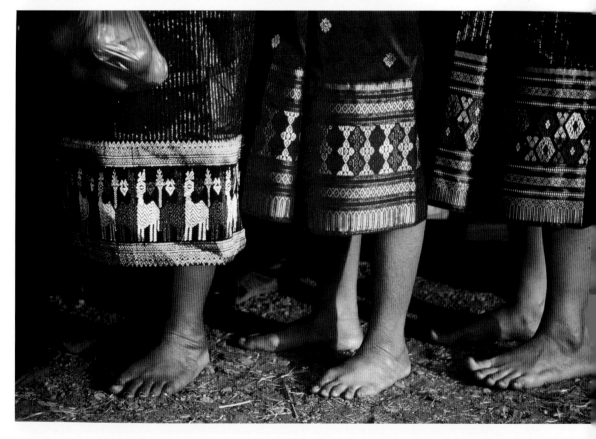

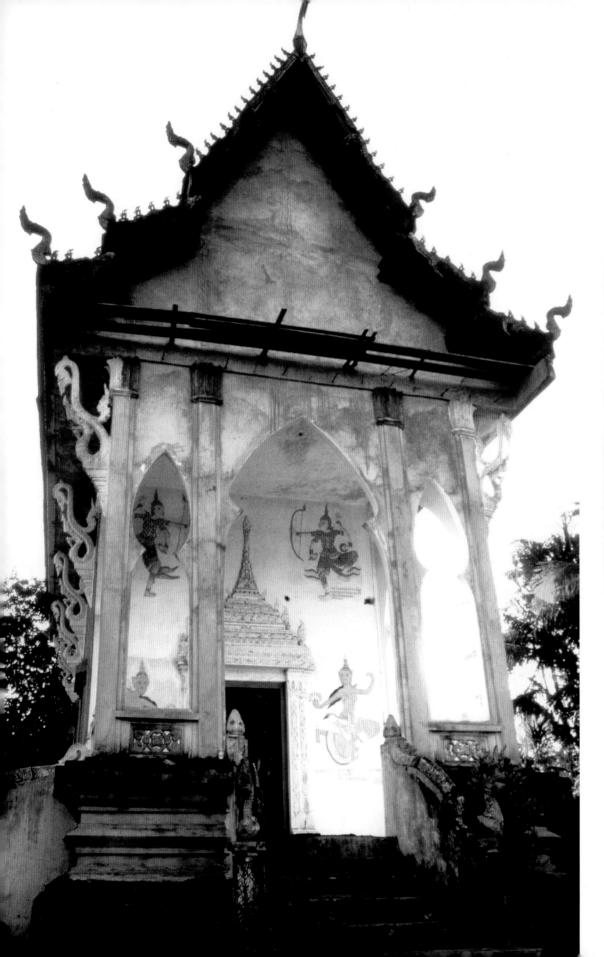

AN ORANGE-CLAD MONK in Vientiane, beneath his customary black umbrella, waits for a bus in the hot afternoon sun. Monks in Laos tend to walk in groups or crowd together in *tuk-tuks*, three-wheel motorized taxis.

A BEAUTIFUL *SIM* (the central sanctuary of a *wat*) stands near Route No. 13 North, not far from Vientiane. This is a Vientiane-type *sim* characterized by its tall and slender shape and its front veranda.

Monks sit inside a *wat* in eastern Vientiane beneath an open window surrounded by colorful frescoes. Ceremonies are held every month at full moon in Vientiane, and for a variety of occasions throughout the year.

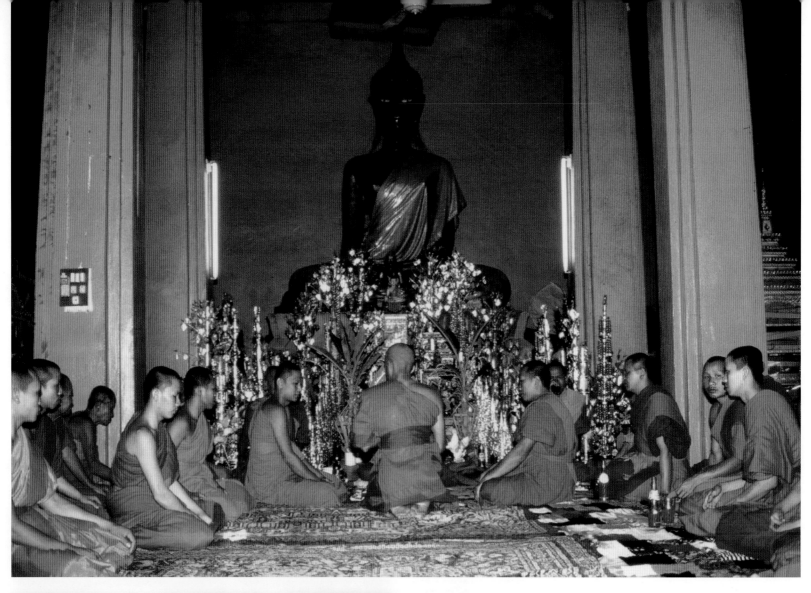

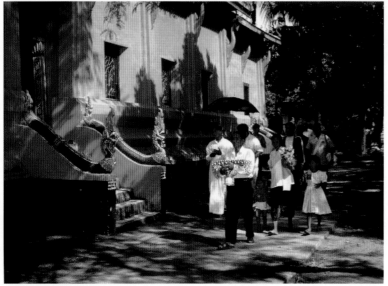

AN ORDINATION CEREMONY is held in a small *wat* beneath a watching Buddha image. On the day of the ceremony, my neighbor (kneeling in the center) had to shave his head and eyebrows and go through the prescribed rituals.

MY NEIGHBORS MARCH TO THE NEARBY *WAT* to attend the ordination ceremony (shown above) of a family member who is becoming a monk for the week before he is married. In this way, the husband-to-be (dressed in a white robe) gains merit for himself and his family.

Two novices look out of a window near the top of the Anusavari Monument.

Although built to commemorate fallen Lao soldiers, the Anusavari Monument, or simply, "the monument," is often called Vientiane's Arc de Triomphe because of its resemblance to the Arc de Triomphe in Paris. It has been designated a tourist site, and visitors are charged a fee to enter. Here it stands serenely at sunset, in the heart of Vientiane.

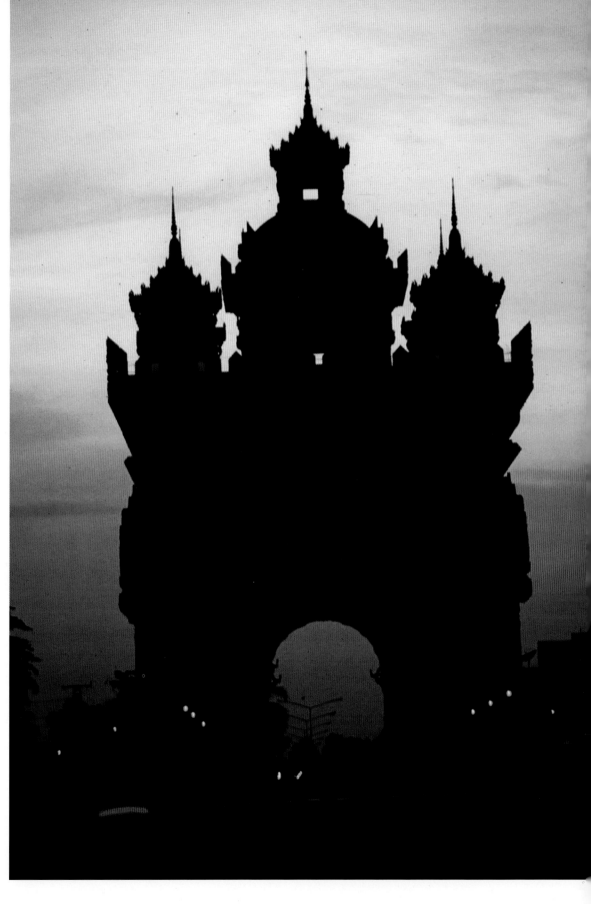

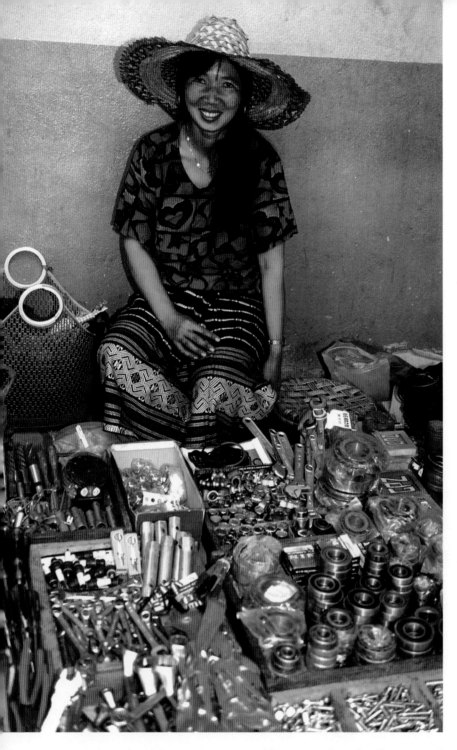

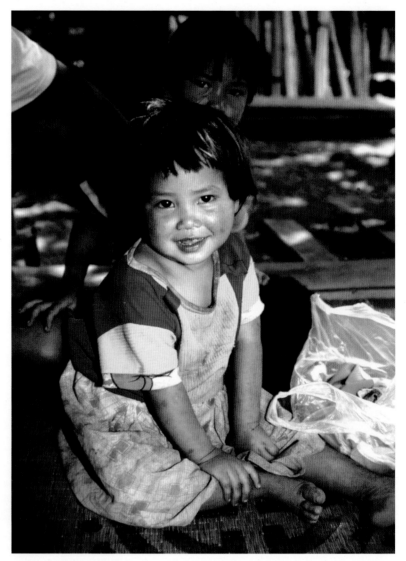

AMI, A ONE-TIME NEIGHBOR and long-time friend, sells nuts and bolts near the evening market (*talat laeng*) in Vientiane. The long hours put in by Ami and her hardworking family have paid off. I have watched her family rise from the working-class poor to middle class with a new, spacious Thai-style house. She no longer has to wade in dirty water in a small, dilapidated house during the monsoon, nor fend off dengue-infected mosquitoes attracted by the water.

ALTHOUGH THIS LITTLE GIRl always had a sunny smile for visitors, she was motherless and did not seem to have much of a future. She was of the Lao Thoeng ethnic minority, and her family had been resettled from the north to a small, poor village 20 km from Vientiane. Her father, a widower, was about to be remarried and could not care for this girl and her three older sisters from his first marriage. The last time I visited, village gossip was that a male American "relative" had adopted the three youngest daughters. The "adoption fee" had been US$3,000 per girl paid to the father and suitcases full of used clothes for the villagers.

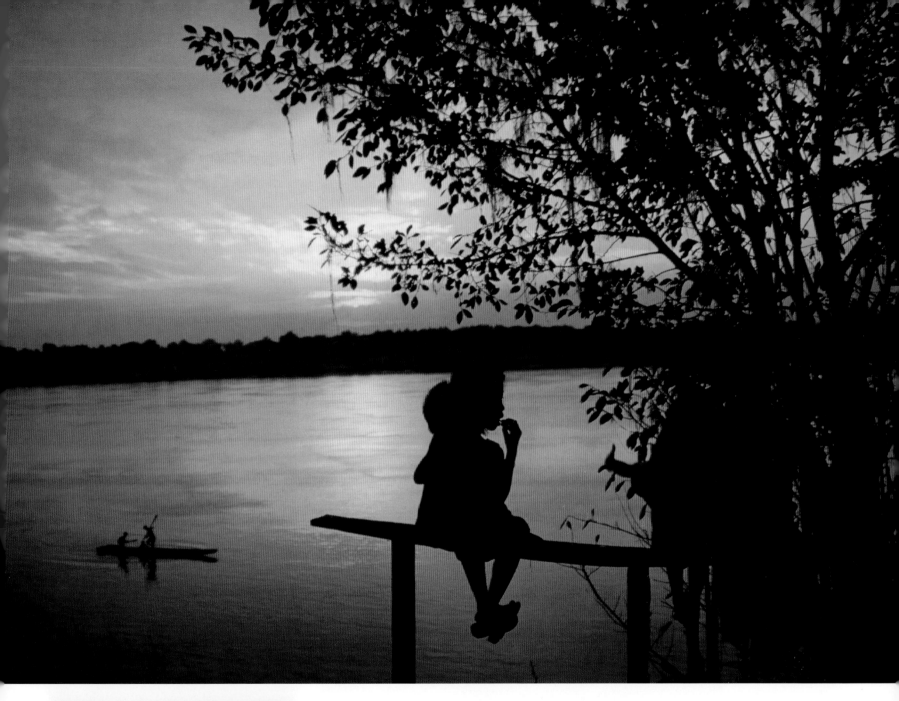

Two children enjoy the view and the stillness of the moment. Vientiane is known for scenes like this picture-perfect sunset mirrored in the Mekong River. The sunsets are especially dramatic during the winter months, when the sun's rays strike the water at the perfect angle. This photo was taken from a trail in the eastern part of Vientiane.

An old loom with time-worn patina sits under a hut in a small village near Nam Ngum Lake. On it is the woven bottom border, *tin sin*, which will be attached to the *sin*, the traditional skirt worn by Lao women. In the early 1990s, nearly every stilt home in Vientiane Province had a loom underneath, and many still do.

AFTER A MAJOR DOWNPOUR, a praying mantis dripping with raindrops scrutinizes me, as if asking for sympathy for its soggy condition. This particular mantis lived on a large branch of a hummingbird tree (*Agati grandiflora*) in my garden in Vientiane. It remained on that same branch, always upside down, day after day, so with time I knew it and it knew me. It captured other insects with lightning-quick strikes and ate them alive, but otherwise it remained deceptively sedentary.

ANOTHER PRAYING MANTIS clings upside-down to a blossom on the hummingbird tree in my garden in Vientiane. I came to recognize individual mantises, and their territories seemed to be restricted to particular branches or blossoms. The mantises were not happy when my landlord came to collect the blossoms. "Good for stir-frying," he claimed.

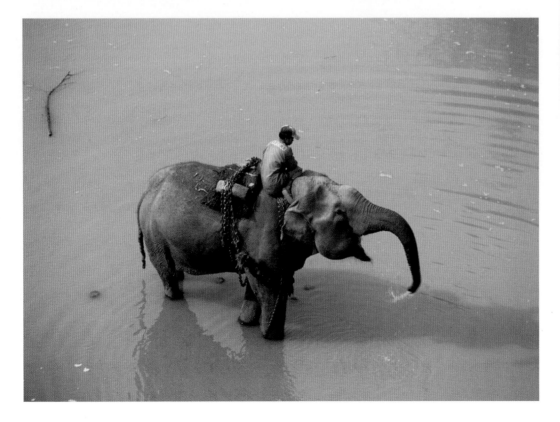

THIS ELEPHANT DESERVES A BATH after a long day of hard work. I occasionally encountered working elephants like this in the countryside west of Vientiane. They were usually dragging logs away from logging sites along dusty roads.

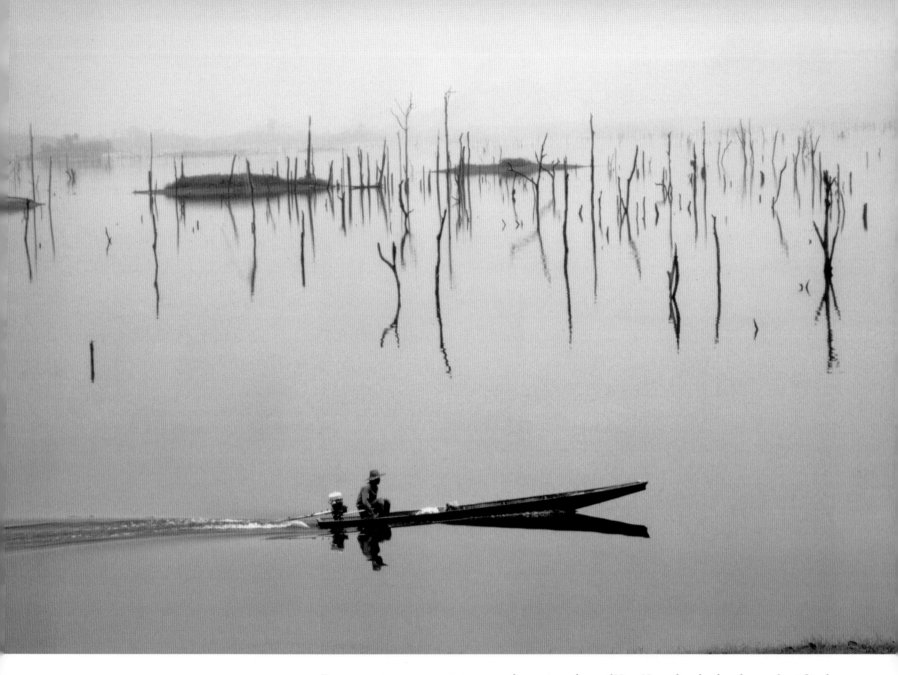

THIS MOTORIZED PIROGUE near the western shore of Nam Ngum breaks the silence of a stiflingly hot afternoon. Although Nam Ngum is a lake behind an artificial dam, it can still be quite picturesque. The trees that emerge from the water are from a forest that was flooded in 1971 after the construction of a hydroelectric dam, the first large dam that was built in Laos. This dam mainly provides electricity to Thailand; it also provides all the electricity for Vientiane. Many small islets formed when the valley behind the dam was flooded, and they are now touted as tourist attractions. Some of the timber preserved in the lake is being logged by boat.

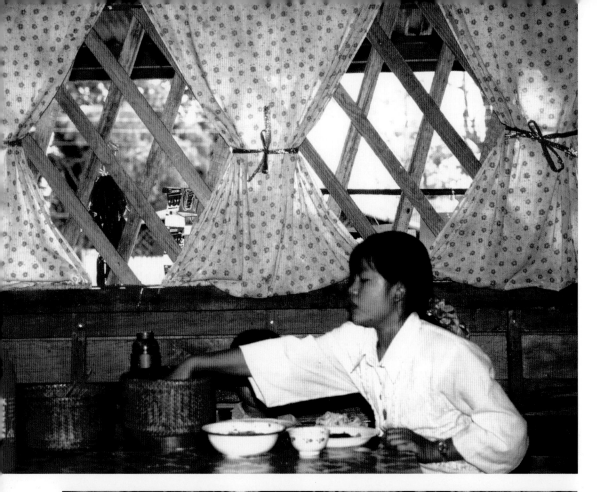

SAVANNAKHET PROVINCE

PATTERNED CURTAINS make this roadhouse in Savannakhet unintentionally quaint. The woman eats sticky rice, which is the staple diet among the Lao Lum. Usually sticky rice is served from a basket used only for this purpose. When sold in the market, hot, steaming sticky rice is wrapped in a banana leaf or put in a plastic bag. The fragrance and taste of such rice rivals any fancy gourmet meal.

PEDDLERS SURROUND a colorfully painted bus in Ban Lak Samsipha, Savannakhet Province. Bus stops like this one are designed so that only departing passengers need to disembark. Vendors sell food and drinks using sticks that reach even passengers on the roof. They sell fruit, candy, boiled eggs, corn on the cob, roasted fish, and "cockroaches" (actually water bugs). Drinks are served in plastic bags with straws.

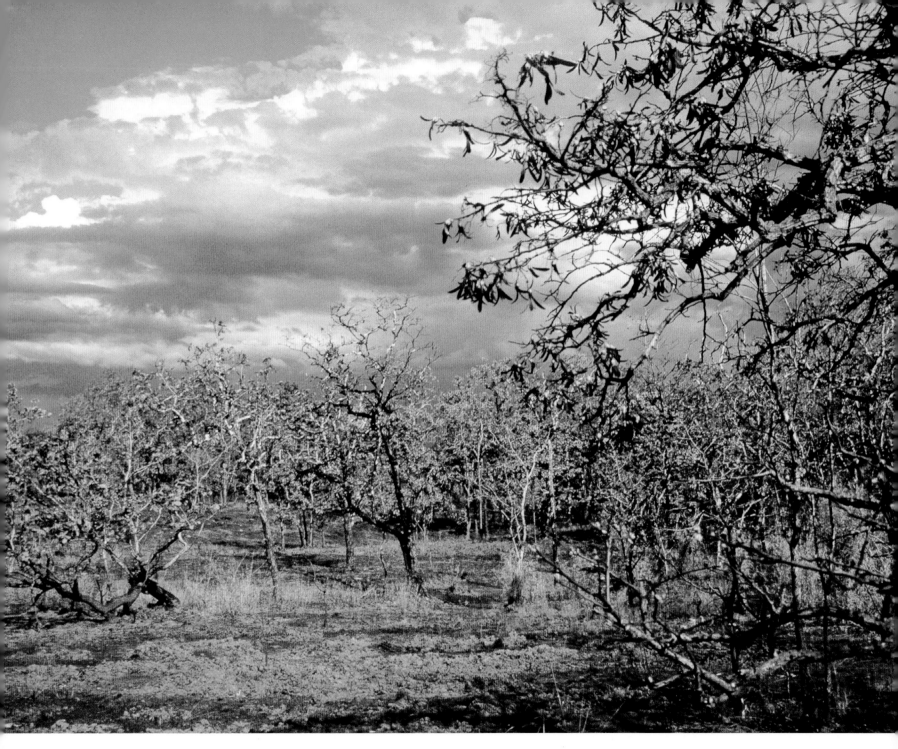

ATTAPUE PROVINCE GNARLED DIPTEROCARP TREES (family *Dipterocarpaceae*) grow on top of a desolate hill. This scene greeted us as we climbed Phu Phanom, a sandstone prominence in the otherwise flat lowlands of Attapue Province. The ground under my feet crunched as if it had never rained. A dry, deciduous, dipterocarp forest like this has an open canopy, stunted trees, can withstand drought, and is resistant to fire. Thus, this forest is perfectly adapted to conditions in Attapue.

BOMB CRATERS FROM THE VIETNAM WAR abound near the Ho Chi Minh Trail in Attapue Province. We passed many craters on our traverses through the jungle, and most craters looked surprisingly fresh considering the time that had passed since the Vietnam War. It is difficult to imagine why such a desolate area was targeted for bombing or why a dipterocarp forest, which has an open canopy in Laos, was sprayed with Agent Orange defoliant. My Lao colleagues grumbled that the forest spirits were angry here. I totally concurred.

WE DID NOT TRY TO FIND OUT whether this well-camouflaged mortar shell in a dry creek had detonated. The rule of the forest in Attapue Province is never to touch anything metallic lying on the ground. The rock hammer on the ground, although metallic, is used for fieldwork and gives scale to the photograph.

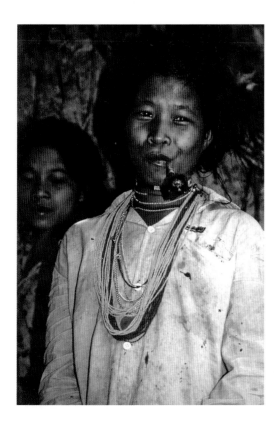

CONTENTEDLY SMOKING A PIPE, this Lave woman from southeastern Attapue Province watches us with amusement as we sample sediment to be analyzed for gold content from a small creek bed. Unlike us, she *knows* where the gold is, and it is not here! In contrast to her elders, she wears a shirt to cover her upper body, but she continues the tradition of wearing thick strands of glass beads.

THIS YOUNG PROSPECTOR in Attapue Province is not impressed by her gold yield, although we were. Day after day, women and children pan for gold in the clear, warm water of mountain streams. The children dip their heads under the water to dig into the riverbed with a big, hand-carved, wooden *dulang* (gold pan). Then, they swirl the water with expertise surpassing a veteran prospector—and a *dulang* is heavy. Every new sediment load yielded tiny gold nuggets and fine gold sand. Our state-of-the-art, plastic gold pans did not measure up. Selling this gold produces some cash income for these people who are used to a subsistence economy.

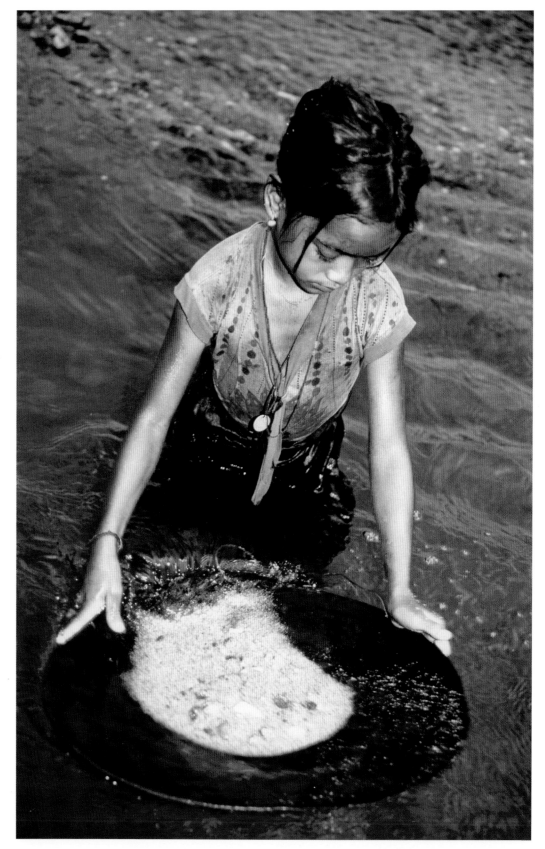

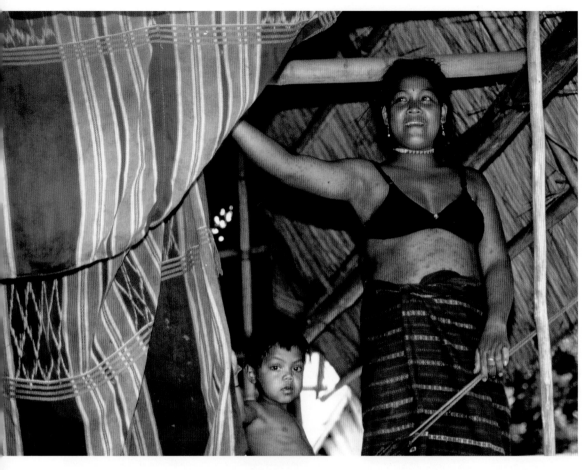

A LAVE WOMAN MODELS the "black brassiere fashion," which is popular among young women. Unbeknownst to the Lave women, such fashion (or lack thereof) would be more appropriate in Bangkok's Patpong, a red light district, than in a remote Lao village. The handwoven curtain shows a pattern typical of Attapue Province. The curtain material was woven on a southern Mon-Khmer back-tension foot loom, which is held by a woman in her lap while she stretches it with her feet. Several pieces of cloth have been stitched together to form the curtain.

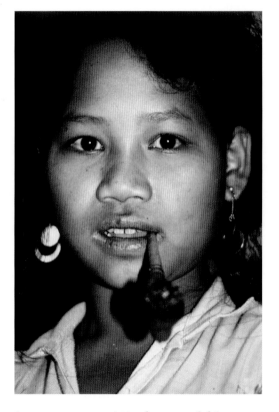

APPREHENSION is in the eyes of this young Lave woman as she encounters a foreigner for the first time, but curiosity takes over. She has abandoned the traditional dress, but still smokes a pipe.

A PUBLIC BUS CROSSES A STREAM in Attapue Province. Every stream crossing is an adventure. This time the bus driver needed some help navigating because of logs floating in the water. Some men in the packed bus got out to help, while everyone else sat waiting patiently and hoped for the best.

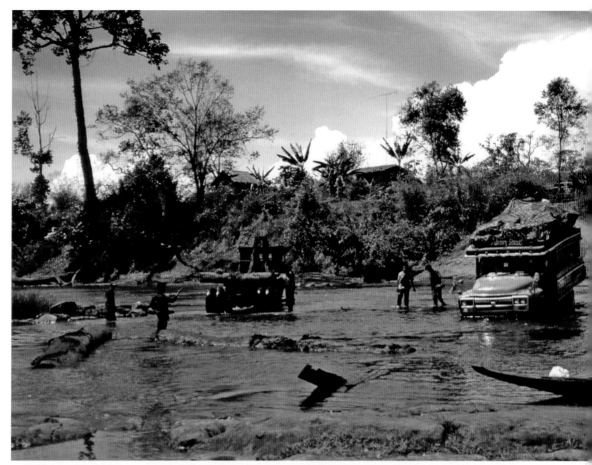

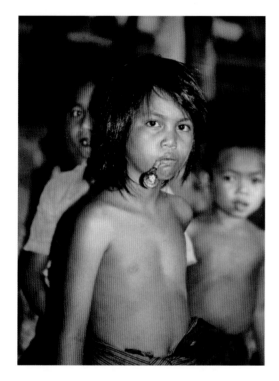

THIS LAVE GIRL, probably seven or eight years old, is smoking a pipe. Among the Lave in southeastern Attapue Province, most women and girls smoke pipes or homegrown tobacco wrapped in banana leaves. My Lao colleagues claimed that "even the babies smoke," a statement I could not verify, and they insisted that pipes are used as pacifiers. It certainly seemed believable.

FLOWERS OF WILD GROUND GINGER (*Curcuma* sp. of the Zingiberaceae family) emerge from leaf litter on the forest floor of Bolovens Plateau. The trees from which the leaves fell were being logged when I took this picture in 1995, and the forest has now probably been replaced by brush.

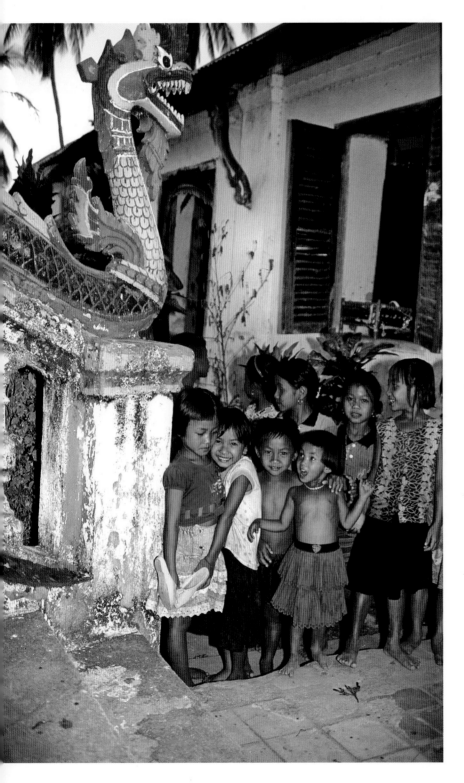

A FALLEN BLOSSOM from a tree (*Careya sphaerica* Roxb. of the Barringtoniaceae family) brightens the decaying leaf litter on the forest floor on the Bolovens Plateau. This tree, native to Africa, is naturalized in Southeast Asia. The blossoms are edible and have medicinal properties, and the tree is perfectly adapted to resist fire, disease, and drought. Winged dipterocarp fruits (Dipterocarpaceae family) and decaying leaves surround the blossom.

A GROUP OF CURIOUS CHILDREN gather by the little *wat* in Ban Feng Deng, Attapue Province. A *naga*, or serpent, guards the *wat* along the railing on the left. Some of the bravest children ran up to touch my blond hair, while the other children squealed with excitement. During this visit, throngs of children followed my every step. Most of them had never seen a foreigner.

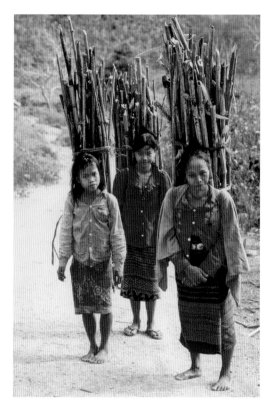

A WOMAN AND TWO GIRLS carry heavy loads of bamboo that they will use for fencing and firewood. They stop to look at the unusual sight of a vehicle on their village road.

DRESSED IN A T-SHIRT on account of visitors' sensibilities and smoking the ubiquitous pipe, a Lave woman returns home from the fields. According to my Lao colleagues, passersby have ridiculed and taunted the Lave people for the topless tradition that used to be the norm. Only the elderly still adhere to this tradition. A T-shirt does not prevent this woman from carrying out her tasks, however—that of collecting firewood, here wrapped in banana leaves and carried in a sling made from vines. Her ears have been extended by ivory plugs fashioned in a time when elephants still plied the forests. These types of plugs are handed down through the generations from mothers to daughters, but daughters no longer want them as it is considered backward to wear them. Eventually, the ivory plugs end up in Vientiane, sold as collectors' items to foreign visitors.

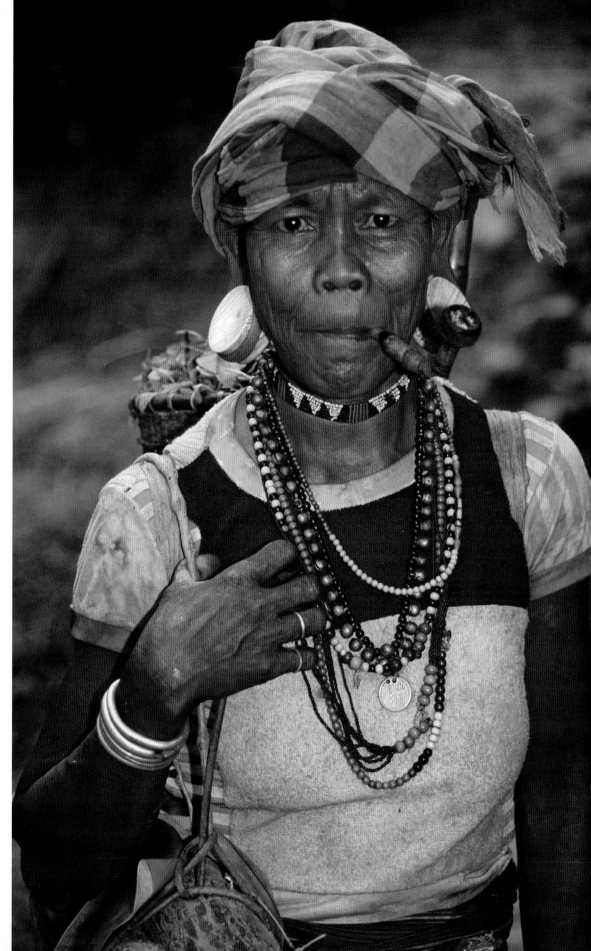

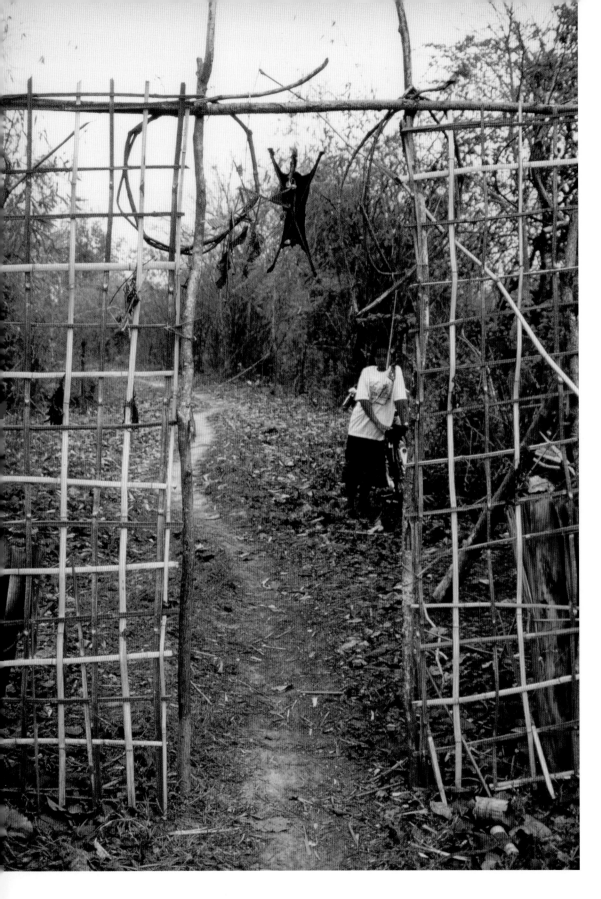

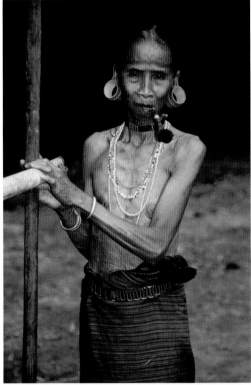

A Lao Toeng Lave woman watches me unfazed. Traditionally, Lave women do not wear clothing on the upper part of their bodies, but this was the only Lave woman I met who still adhered to this tradition. Perhaps the "last of her kind," she has a tattoo on her forehead, signifying the hill tribe to which she belongs, and bamboo plugs stretching her earlobes.

This somewhat dilapidated "spirit gate" guards a village in Attapue Province from evil forest spirits. When a villager returns after being outside the village, walking through the spirit gate rids him of any evil spirits that may have hitched a ride. My Lao colleagues would not, under any circumstances, walk through a spirit gate, although they never told me why.

A MYSTERIOUS SPIRIT ALTAR, about 1.5 m high, stands outside the "spirit gate" to a remote village in Attapue Province. The altars and gates were undoubtedly built to appease the forest spirits. For reasons unknown to me, a small ladder connects the lower platform to the ground. Ritual baskets of food have been placed on the larger platform.

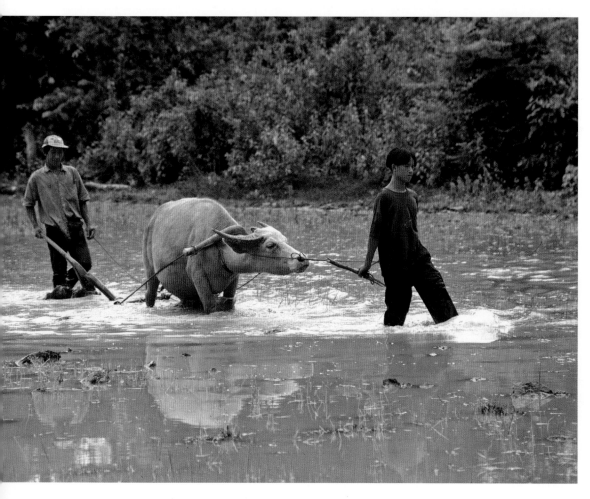

A PINK WATER BUFFALO PLOWS a rice paddy in this secluded valley at the end of a karst tunnel. Pink buffaloes are as common in Bolikhamsai Province as in other parts of Laos. In remote, roadless areas like this, plows are still pulled by water buffaloes.

BOLIKHAMSAI PROVINCE

A COLORFUL, NETTED STINKHORN mushroom of the Phallaceae family grows along Route No. 8 in Bolikhamsai Province. This mushroom family commonly produces a foul-smelling slime that attracts flies, although this particular specimen did not stink. The skirt-like net is appended to the cap and partially obscures two stalks underneath.

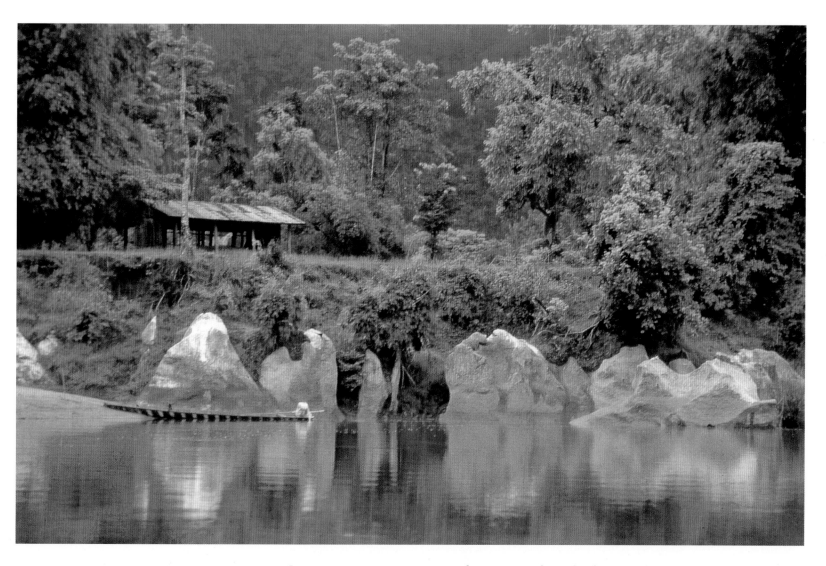

LIMESTONE OUTCROPPINGS line a tranquil riverbank. Rugged, karst terrain is common in Bolikhamsai Province and may hide many wonders and surprises. This river entered a 7-km-long, natural tunnel carved by water right through a mountain. I soon realized that the term "tunnel" was a vast understatement as we traveled upstream by a motorized pirogue through a veritable subterranean wonderland. Cathedral-like rock ceilings, mountains within the mountain, crystal-clear lakes, and tranquil beaches would have qualified this cave system as a national monument in most countries! The river served as the only exit for the inhabitants living in a totally enclosed valley near the headwaters of this river.

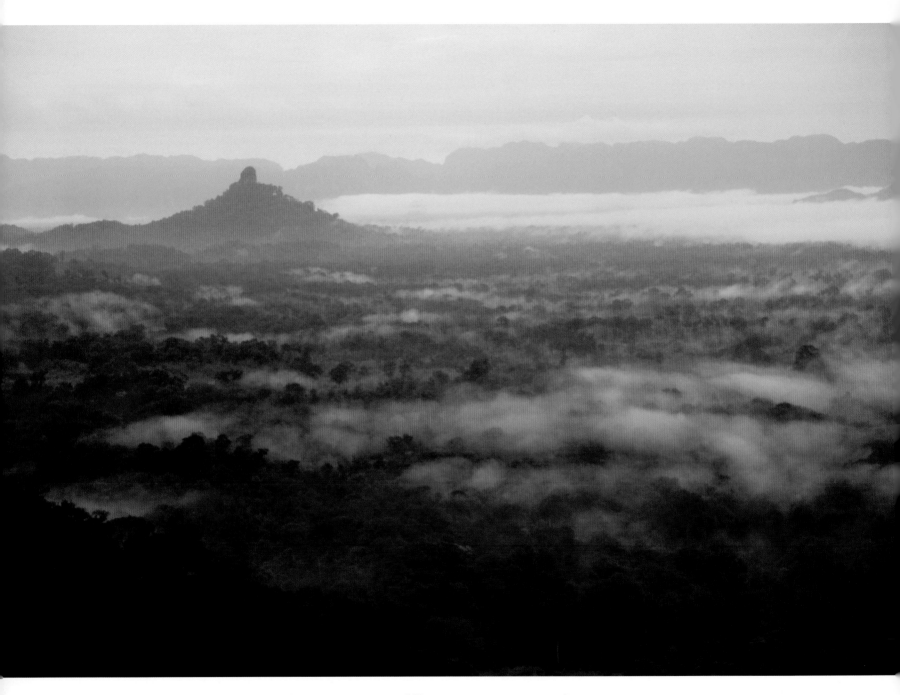

THE VIEW OVER NAM THEUN VALLEY from Route No. 8 in Bolikhamsai Province is spectacular.
The Nam Theun 2 hydropower project may have now flooded this area.

A DEAD TREE stands on a hill in front of rugged, karst terrain along Route No. 8 in Bolikhamsai Province. Lush green trees are growing in the crevices between the gray limestone peaks. According to my Lao colleagues, some wildlife still survives among these craggy peaks "because hunters would get lost." The new, improved road we were traveling on had recently and relentlessly been hacked through this fragile landscape. The road was so new that much of the natural environment was still untouched by logging, shifting cultivation, or new settlements. Seventeen years later, this road is in such disrepair that it cannot be traveled for most of the year—perhaps a fortunate reprieve for the plants and wildlife in this karst area.

ACKNOWLEDGMENTS

I would first like to thank Trasvin Jittidecharak, publisher of Silkworm Books, for seeing the potential in my book project so many years ago. I am indebted to Susan Offner, my editor, for her unwavering professionalism, her steady guidance, and perfect suggestions, and for her research help. Because of Susan it has been a smooth ride.

Ed Berg challenged me to complete this book. Thank you, Ed—I cannot resist a challenge! I thank my son Oliver, Lucy and George Cutting, and many other friends for their encouragement. I am grateful to David Van Alstine for mercilessly editing my wayward grammar. Philavan Khanthong patiently explained Lao customs, however trivial; he and other Lao friends taught me the meaning of Lao hospitality and made me feel like a family member. My Lao geologist colleagues introduced me to the rules of the bush, to Lao village etiquette, and to the Lao spirit world.

Many of the photos in this book would not have been possible without the consent of my Akha friends, whose culture is threatened by extinction. These wonderful people living in remote mountain villages overcame their shyness to welcome a foreigner into their midst. I will strive to ensure that they benefit from this book.

NOTE

For my photographs, I used a Nikon F90 35-mm SLR camera with a Nikon AF Zoom Nikkor 35–135mm f/3.5~4.5s lens, as it was versatile out in the bush and I did not want to carry more than one lens. I used a Nikon AF SB-24 TTL Speedlight flash, when necessary. The film was slide film, mainly Kodachrome 64 and Fuji Velvia (ASA 50).